The Spitz Master

A Parisian Book of Hours

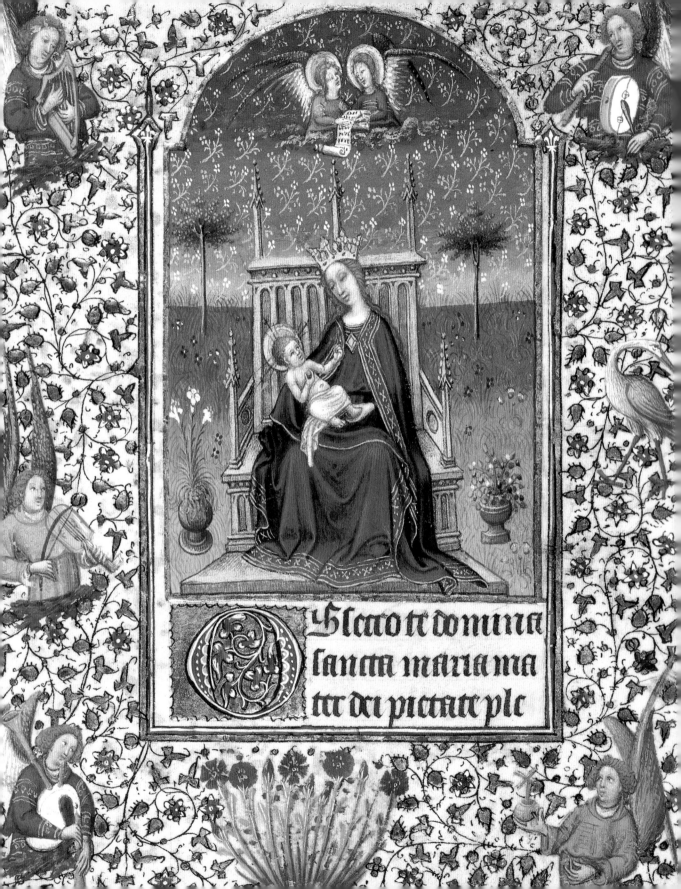

The Spitz Master

A Parisian Book of Hours

Gregory T. Clark

GETTY MUSEUM STUDIES ON ART

Los Angeles

For Nicole Reynaud and François Avril

Getty Publications
1200 Getty Center Drive, Suite 500
Los Angeles, California 90049-1682
www.getty.edu

Christopher Hudson, *Publisher*
Mark Greenberg, *Editor in Chief*

Mollie Holtman and Tobi Kaplan, *Editors*
Diane Mark-Walker, *Copy Editor*
Jeffrey Cohen, *Series Designer*
Suzanne Watson, *Production Coordinator*
Christopher Foster, *Photographer*

Typeset by G&S Typesetters, Inc.,
 Austin, Texas
Printed in Hong Kong by Imago

Library of Congress
Cataloging-in-Publication Data

Clark, Gregory T., 1951–
 The Spitz master : a Parisian book of
 hours / Gregory T. Clark.
 p. cm. — (Getty Museum studies on art)
Includes bibliographic references.
 ISBN 0-89236-712-1
 1. Spitz hours—Illustrations. 2. Spitz
master, act. ca. 1415–25. 3. Illumination of
books and manuscripts, French—France—
Paris. 4. Illumination of books and
manuscripts, Gothic—France—Paris.
5. Illumination of books and manuscripts—
California—Los Angeles. 6. J. Paul Getty
Museum. I. J. Paul Getty Museum. II. Title.
III. Series.
 ND3363.S68 C57 2003
 745.6'7—dc21

 2002152390

Cover:
Spitz Master (French, act. ca. 1415–25). *Saint Christopher Carrying the Christ Child* [detail]. Spitz Hours, Paris, ca. 1420. Tempera, gold, and ink on parchment bound between pasteboard covered with red silk velvet, 247 leaves, 20.3 × 14.8 cm (7 15/16 × 5 7/8 in.). Los Angeles, J. Paul Getty Museum, Ms. 57, 94.ML.26, fol. 42v (see Figure 7).

Frontispiece:
Spitz Master, *The Virgin and Child Enthroned* [detail]. Spitz Hours, fol. 33v (see Figure 6).

The books of the Bible are cited according to their designations in the Douay-Rheims version translated from the Latin Vulgate.

Full-page illustrations from the Spitz Hours are reproduced at actual size.

All photographs are copyrighted by the issuing institutions, unless otherwise noted.

CONTENTS

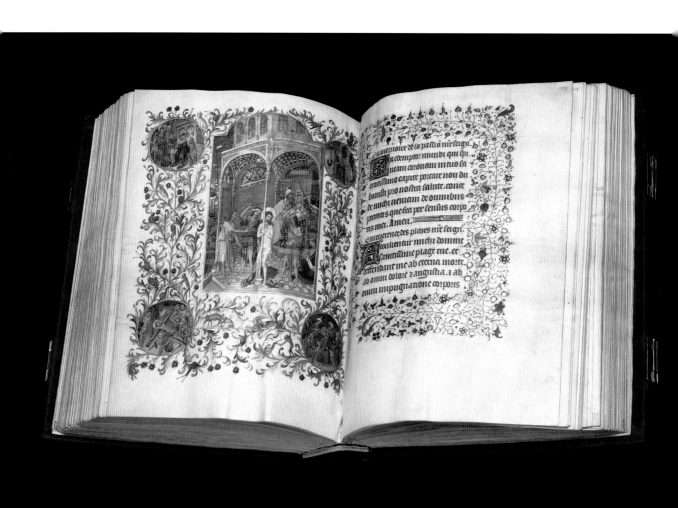

onmemoire de la passio nre seigni
iesu cedemptor mundi qui spi-
neam coronam in tuo sa-
cratissimo capite portare non du-
bitasti pro nostra salute. concee
de michi veniam de omnibus
peccatis que feci per sensus corpo
ris mei. Amen.

Enta recete des plaes nre seigni
Auxientur michi domine
sacratissime plage tue. et
descendant me ab eterna morte.
ab omni dolore z angustia. z ab
omni impugnatione corporis

INTRODUCTION

A work of art that documents a major shift in aesthetic direction at a specific time and place is always an object of considerable significance. When that work is also both little known and an artistic tour de force, its study promises to be especially rewarding. The subject of this essay, a book of hours made in Paris in the years around 1420, is just such a work of art [FIGURE 1].

While neither its first owner nor its owners over the course of the first four centuries of its existence can be identified, it is known that the volume came into the possession of Sir Robert Holford of Westonbirt in Gloucestershire, England, around 1845. It remained in his descendants' hands until 1929, when it was auctioned at Sotheby's of London; the buyer was the London book dealer Quaritch. At some point between 1929 and 1938 the volume crossed the Atlantic and entered the collection of the prominent New York bibliophile Cortlandt Field Bishop. Auctioned at his sale in 1938 at the Anderson Galleries in New York, the book was purchased by the noted medieval collector Ernst Brummer. In 1947 the volume was acquired by Joel and Maxine Spitz of Glencoe, Illinois; it was still in their possession in 1974, when the American scholar Millard Meiss named it the Spitz Hours. In 1994 the J. Paul Getty Museum purchased the book from a private American collector.

Today the closed volume measures some eight inches in height, six inches in width, and two inches in depth. These dimensions are generous but not exceptional for late medieval books of hours. The volume's binding of red silk velvet over pasteboards is a mid-twentieth-century replacement for one or more earlier coverings. That the book was once larger is suggested both by the cropped antlers of the stag at the top of the page with *The Visitation* [FIGURE 12] and by the missing tips of the angels' wings at the apexes of six other pages with large miniatures [FIGURES 4–6, 8, 11, and 17]. These excisions indicate that the volume originally had even more generous margins that were trimmed over the course of one or more rebindings.

The Spitz Hours is a manuscript, that is, a text written by hand, as were all European texts before the advent of printing in the fifteenth century. Although paper was being manufactured in France already by the middle of the fourteenth century, the Getty Museum manuscript is written on 247 leaves of stretched and prepared animal hide called parchment. The makers of the Spitz Hours chose parchment over paper because the former was a better support for the painted decoration that was destined to embellish the text. That decoration, described collectively as illumination, comprises one small and twenty-one large miniatures, or large pictorial illustrations, within narrow burnished-gold frames; three historiated initials, that is, introductory initials containing figural imagery; floral borders in pen and ink, burnished gold, and colors surrounding every miniature and every block of text; and innumerable initials in burnished gold and colors within every block of text.

Just as their writing by hand makes every manuscript unique and therefore a deserving object of study for textual historians, their decoration by hand makes every illuminated manuscript singular and thus a worthy object of study for art historians. Because the Spitz Hours is blessed with superior illumination that bears witness to an important stylistic shift in Parisian book painting in the years around 1420, this essay will focus primarily on the manuscript's decoration. Before turning to that decoration, however, we must take a moment to consider the origins and character of the book's texts.

WHAT IS A BOOK OF HOURS?

The liturgy, or public worship, of the Christian church takes two distinct forms: the Mass and the Divine Office. The former celebrates the sacrificial rite of the Eucharist; its texts are contained in the missal. The latter comprises the daily round of devotional prayer; its texts are found in the breviary.

The Divine Office is divided into eight separate prayer services or Hours for each day: Matins (before dawn), Lauds (daybreak), Prime (6:00 a.m.), Terce (9:00 a.m.), Sext (noon), None (3:00 p.m.), Vespers (sunset), and Compline (evening). The Mass, by contrast, was usually celebrated once each day, between Terce and Sext, that is, around 10:00 or 10:30 a.m. For medieval laypeople, listening to the Mass and reciting the Divine Office on a daily basis was possible only for the leisured classes. If a layperson owned just one of the two principal liturgical texts (and most owned neither), it was usually a breviary or, even more commonly, a psalter, that is, a copy of the Old Testament Book of Psalms subdivided for recitation as part of the Divine Office. Because prayer services did not require the presence of a celebrating priest, the breviary and psalter were the laity's favored liturgical books. At the end of the twelfth century, how-

ever, an abbreviated devotional text derived from the breviary, the book of hours, started to gain popularity. This would prove to be the most frequently copied and printed text—religious or lay—of the late Middle Ages.

Although the Virgin Mary, the mother of Jesus Christ, is only infrequently mentioned in the New Testament after Matthew's and Luke's descriptions of her son's conception and birth, devotion to her, and especially belief in her power to intercede for individual souls at the time of judgment, dates back at least to the early fourth century. The Virgin's status as the *Theotokos* (Bearer of God) was confirmed at the Council of Ephesus in 431; the first great church dedicated to her, Santa Maria Maggiore (Saint Mary Major) in Rome, was erected in the 430s.

To judge from the scanty surviving evidence, the Office of the Blessed Virgin Mary began to take shape in the eighth or ninth century. By the tenth it appears that the Hours of the Virgin as we now know it existed as a fully formed text; the earliest manuscripts containing those Hours, however, date only from the eleventh century. Over the course of the twelfth and thirteenth centuries, the Hours of the Virgin and the Psalms were separated from the breviary to create the psalter-hours, the hybrid prayer book favored by the upper-middle-class and aristocratic laity.

By the late thirteenth century, however, the increasingly literate but not entirely leisured urban middle classes sought a devotional text that could more reasonably be recited once a day. To meet their needs, the Hours of the Virgin were separated from the psalter and enriched with four texts also borrowed from the breviary: the calendar, the Seven Penitential Psalms, the litany of saints, and the Office of the Dead. The Hours of the Virgin was thereby reborn as the central and most important component of the book of hours.

Like those for each Hour in the breviary, the readings for each of the eight Hours of the Virgin include invitatory phrases, a hymn, three psalms, a "little chapter" (*capitulum*), and a prayer (*oratio*) or prayers (*orationes*). Sprinkled generously among these are short exclamations called antiphons, versicles, and responses. To these the longest Hour, Matins, adds biblical and patristic readings known as lessons. But while the readings in the breviary vary for each day of the liturgical year, the readings in the Hours of the Virgin vary only slightly at Advent, the penitential period that begins four Sundays before Christmas Day, and at Christmastide itself.

Because the Hours of the Virgin do not change on a daily basis, the book of hours is a quasiliturgical book, and more specifically a prayer book with readings drawn from the breviary. Most books of hours also contain a short passage from each of the four Gospels of the New Testament known collectively as Gospel Sequences; two other Hours, those of the Cross and of the Holy Spirit;

suffrages (supplications) addressed to favorite saints; and prayers addressed to Christ and, especially, the Virgin.

Although its texts were derived from the breviary, the book of hours was a very different kind of book. First and most obviously, it was considerably abbreviated and thus more quickly read; second and more important, its quasi-liturgical character partly removed it and its readers from the traditional public worship of the Christian church. Both the Mass and the Divine Office were first and foremost shared experiences. The celebration of the Mass was seen and heard by the priest's deacons and the faithful; the recitation of the Divine Office was shared by the clerics, monks, and laypeople who gathered to hear and say it at the eight canonical hours of the day. By contrast, reading the book of hours was a solitary, private experience that drew the devotee inward toward contemplation rather than outward toward a communal liturgical ritual.

The runaway success of the book of hours makes it clear that many late medieval laypeople, immersed though they were in worldly activities, wished to retreat for at least some small part of their day into the reflective and meditative life enjoyed by monastics. And while the book of hours was an ideal medium for such a retreat, it also reaffirmed the fundamentals of church doctrine. Both its texts and its images emphasized the Virgin in her roles as Mother of God, as cosufferer with her son during his final mortal hours, and as intercessor for individual souls. In the following chapter, we will look at the texts and images in the Spitz Hours itself.

THE TEXTS AND MINIATURES
OF THE SPITZ HOURS

Although unillustrated manuscript books of hours were produced throughout the late Middle Ages, they have not survived in large numbers. Once the reading of books of hours fell out of general favor around the middle of the sixteenth century, most undecorated copies were discarded or the parchment leaves scraped clean of text and decoration and reused. A majority of the books of hours that have come down to us are those with illuminations, for these appealed to later generations in their own right.

A modestly illustrated book of hours might only have some five miniatures or historiated initials: three introducing Matins of the Hours of the Virgin, Cross, and Holy Spirit; a fourth prefacing the Penitential Psalms; and a fifth before the Office of the Dead. More ambitious books of hours could have tens, scores, occasionally even hundreds of illuminations. With twenty-two miniatures and three historiated initials, the Spitz Hours' decoration is perhaps best described as generous but not sumptuous.

Given both its dimensions and its decorative program, it seems most likely that the Getty Museum manuscript was made to order rather than selected from a bookseller's stock of ready-made volumes. While it may seem surprising that the Spitz Hours contains no marks of original ownership, many even more luxurious late medieval books of hours are also devoid of such indicators. To judge from its excellent condition, the book was treated by its many generations of owners in the same way they treated their finest heirlooms: as a treasure to be brought out and handled only on special occasions. That the Getty manuscript was made to be cherished is suggested by its still wide blank margins, which have served to prevent any damage to the painted areas by soiled or careless fingers.

Although the texts of the Hours of the Virgin do not vary daily as do those of the breviary, some texts in books of hours do contain variant readings that are peculiar to a specific ecclesiastical diocese or region. Those variants are

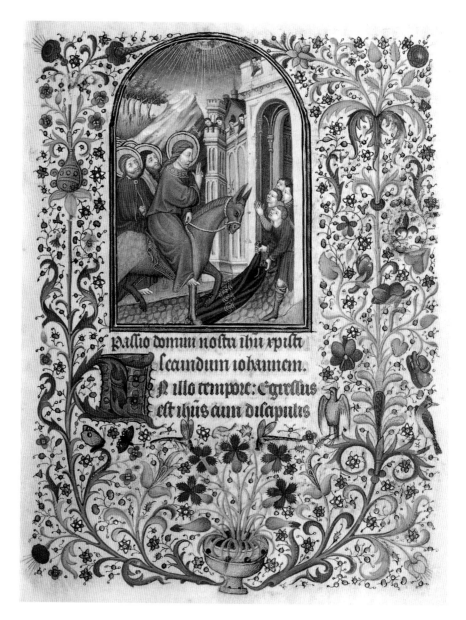

invaluable for localizing the book, that is, for determining where it was written to be used. The most valuable texts for localization are the calendar, the litany, the Hours of the Virgin, and the Office of the Dead. In the Spitz Hours, the last two of those four texts follow the use of Rome, the most widely followed one in late medieval western Europe, and only universally revered saints are petitioned in the litany. The calendar, on the other hand, contains a number of saints

6

especially venerated in Paris and its environs. As we will see, the styles of the three artists responsible for the book's twenty-five illustrations strongly suggest that the Getty Museum manuscript was made in Paris as well.

The first illumination in the book introduces the Passion Passage from the Gospel of Saint John, a text that began to appear in books of hours in the early fifteenth century [FIGURE 2]. The sequence opens with verse 1 of chapter 18, where we learn how Christ and his apostles crossed the Cedron in order to enter and pray in the garden of Gethsemane; it concludes with the description of Christ's hasty entombment after his death by crucifixion (19:42).

In most late medieval books of hours, the Passion Passage from John is illustrated with one or more of the momentous events that transpired in Gethsemane. In this manuscript, however, the two most popular of those subjects, the Agony in the Garden and the Betrayal of Christ, were appropriated to introduce Passion prayers [FIGURES 20–21] by the book's principal artist, the anonymous painter known from this manuscript as the Spitz Master. As a consequence, the painter responsible for illustrating the Passion Passage, the Guise Master, had to turn to an earlier event in Holy Week, Christ's Entry into Jerusalem on the Sunday before Passover, now celebrated in the Christian calendar as the feast of Palm Sunday.

From Matthew (21:1–11), Luke (19:35–56), and John (12:12–15), we learn that just before Jesus entered the Holy City for the last time he mounted a colt and an ass so that he could ride into Jerusalem, where he was met by townspeople who strewed palm fronds and garments in his path. In our miniature, the crowd at the city gate has been reduced to four youths, one of whom lays out his cloak before the Savior. Six boys, three of them holding palm fronds, are visible above the battlements. Behind Jesus follow his apostles.

While prefacing the Passion Passage from John with a miniature is not at all unusual in manuscript books of hours, it is most unusual to enrich the text with a second illustration, as is the case in this manuscript [FIGURES 3a–3b]. That small miniature directly follows John 19:30, which describes how the crucified Jesus, having accepted vinegar

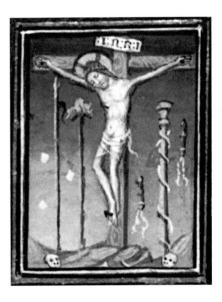

Figure 3a
Master of the Hours of François de Guise, *The Crucifixion*. Spitz Hours, fol. 22v.

Figure 3b
Master of the Hours of François de Guise, *The Crucifixion* [detail]. Spitz Hours, fol. 22v.

7

from a sponge hoisted on a javelin, "said 'it is accomplished,' and bowing his head, gave up the spirit." The illumination depicts the Savior nailed to the wood on Golgotha, the hill of execution just outside Jerusalem. There he is flanked by two skulls and by instruments of his Passion. On his left side (the viewer's right) are three of the torture devices that he endured before his crucifixion: the column at which he was flogged and two of the flails that battered him. On his right side (the viewer's left) are two of the instruments that tormented him after his nailing: the javelin bearing the vinegar-drenched sponge and the lance that was driven into his side immediately after his death, which drew blood and water.

The Gospel Sequences are usually the first texts to follow the calendar in fifteenth- and sixteenth-century manuscript books of hours [FIGURE 4]. They present one excerpt from each of the four Gospels. But, while the order of the four authors in the Bible is Matthew, Mark, Luke, and John, the Gospel Sequences in books of hours are ordered according to the chronology of the events that they describe.

The excerpt from John (1:1–14) that begins below the miniature commences "in the beginning was the Word, and the Word was with God, and the Word was God"; it concludes with the announcement that the Word became flesh and dwelled among humankind. John's passage is followed by that of Luke (1:26–38), where we read of the archangel Gabriel's annunciation of Jesus' incarnation to his mother, Mary, in Nazareth and Mary's acceptance of her role as bearer of God. The third passage, from Matthew (2:1–12), tells the story of the three magi who brought gifts to the newborn Savior in Bethlehem. In the excerpt from Mark (16:14–20), we learn of Jesus' appearance to his disciples in Jerusalem after his resurrection, of his final words to them, and lastly of his ascension into heaven.

In most illuminated manuscript books of hours, each Gospel Sequence is prefaced by a portrait of its author. The Getty book employs a less frequently encountered scheme: all four passages are introduced by one miniature by the Spitz Master in which all four evangelists are shown writing their Gospels. Slender matte-gold lines divide the rectilinear portion of the illumination into the four needed compartments; a burnished-gold sun emanating wavy rays fills the lunette at the miniature's apex. In each compartment, an author sits in a wooden chair fitted with a sloping writing desk. A pen case, a lead weight, and a scroll hang over the far side of each evangelist's desk.

From the miniature alone it is impossible to determine with certainty which author is which. In the floral borders beyond the illumination, however, we find the four creatures described in Apocalypse 4:6–7 as flanking the throne of the Lord and identified in the Middle Ages with the four evangelists: at the upper left, the eagle of John; at the lower right, the ox of Luke; at the lower left, the lion of Mark; and at the upper right, the creature of Matthew, identified in the

8

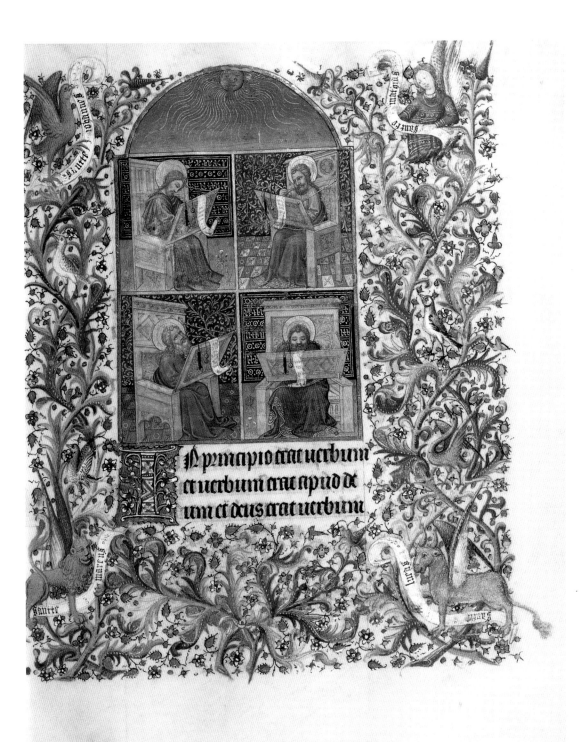

In principio erat verbum
et verbum erat apud de
um et deus erat verbum

Apocalypse as a man but usually rendered in late medieval art as an angel. Each creature also holds a scroll that identifies its master. While John, Matthew, and Mark are positioned at forty-five-degree angles to the viewer, Luke is seated frontally. Other, more subtle means are used to differentiate the first three evangelists: John looks down at his text; Matthew examines the nib of his quill pen; and Mark gazes heavenward.

If we read the miniature as we would a text, that is, from left to right and from top to bottom, the arrangement of the four authors in the Getty miniature is puzzling, for they are ordered neither as their Gospels appear in the Bible nor as their Sequences appear in books of hours. To make sense of their ordering, we must look at the miniature as if it were a blazon, or coat of arms.

First developed in the twelfth century, a blazon was a design of fixed elements (charges) in a set arrangement and in fixed colors (tinctures) that usually covered the whole surface of a shield or flag. Blazons were consistently and exclusively employed within a particular region by a single person, family, or corporation as a mark of identity and authority. Although lacking in the Spitz Hours, blazons were often painted into late medieval manuscripts, most frequently in the borders [FIGURES 31, 38, 59, 61, and 63].

In the Spitz Hours representation of the four evangelists, matching carpets of greenery and rectilinear backdrops in black and gold link the upper left (first) and lower right (fourth) quadrants, and similarly tiled floors and identical curvilinear backdrops in red and gold connect the upper right (second) and lower left (third) quadrants. In medieval blazonment, the charges in the first and fourth quadrants of quartered coats of arms are described first, and the charges in the second and third quadrants are addressed second. Identifying the occupants of the Spitz quadrants in this order yields John, Luke, Matthew, and Mark—the same order as their sequences in medieval books of hours.

Following the Gospel Sequences in the Spitz Hours is a second, abbreviated Passion Passage from John that is most unusual in late medieval books of hours. The passage is drawn entirely from chapter 19. It begins with the description of Jesus' scourging in verse 1 and concludes with the affirmation of the piercing of the dead Savior's side with a lance in verse 35.

The passage is prefaced with a depiction of the Way to Calvary by the Spitz Master [FIGURE 5]. All four Gospels agree that after Pilate condemned Christ to death, the prisoner was led out of Jerusalem carrying his own cross and taken to Golgotha, where he was crucified. On the way, a man named Simon of Cyrene was made to help Jesus bear the heavy wood. In the miniature's foreground, one black and three white soldiers push and pull Jesus just as he exits the Holy City that he had entered triumphantly only five days before [FIGURE 2]. The Savior uses both hands to steady his cross, the vertical beam of which

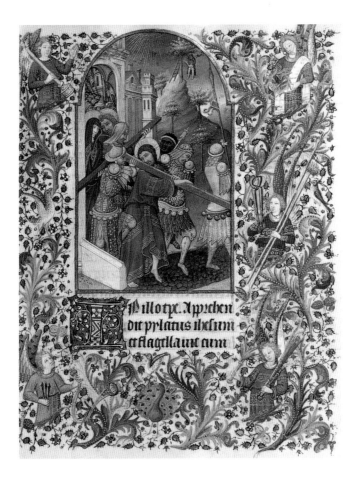

weighs heavily on his right shoulder. Just behind him stands Simon of Cyrene, who grasps the other end of the wood to lessen Christ's burden. John, Jesus' favorite disciple, and the distraught Virgin head the crowd that follows.

In the background, a partly exposed male corpse hangs by a noose from a tree with a ladder propped against its trunk. The man is Judas, one of Christ's twelve disciples, who the night before had betrayed his master to his enemies in Gethsemane for thirty pieces of silver. From Matthew (27:3–5) we learn that the turncoat, filled with remorse over his treachery, returned the money the next day to those who had bribed him and then hanged himself.

In most medieval depictions of the moment of death, the soul takes the form of a tiny, childlike figure that escapes out of the mouth of the deceased with his or her last breath. But because the noose closes off Judas's windpipe, the unfortunate soul must exit through the suicide's belly, which has burst open to expose the entrails. The soul's effort to flee rightward toward salvation is in vain,

Figure 5
Spitz Master, *The Way to Calvary*. Spitz Hours, fol. 31.

11

however, for a devil already waits at Judas's left side to snatch his soul away to its infernal reward.

In the floral borders, five angels display a full array of Passion instruments. In the inner border, one angel bears the column of the flagellation and another proffers the three nails that affixed Christ to the cross. The angel at the top of the outer border holds the crown of thorns, and the one below carries the pincers that removed the three nails, the spear with the vinegar-soaked sponge, and the lance that opened up the Savior's side. At the bottom of the outer border we see in the hands of the fifth angel the flails that rent Jesus' flesh at the column of flagellation.

At the end of the preceding chapter, it was mentioned that medieval devotion to the Virgin—and the popularity of the book dedicated to her, the book of hours—was inspired by her exceptional roles as Mother of the Savior, as cosufferer with her son during his Passion, and as personal intercessor with him on

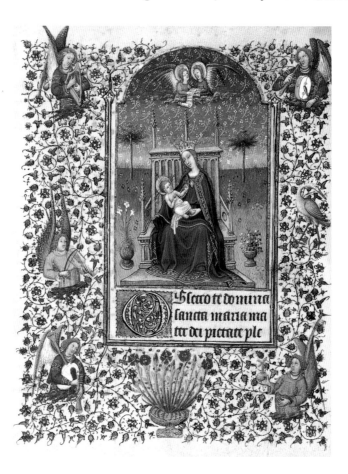

Figure 6
Spitz Master, *The Virgin and Child Enthroned.* Spitz Hours, fol. 33v.

12

behalf of individual souls at the final reckoning. Her unequaled position as an intercessor is made clear in contemporary depictions of the Last Judgment, where she sits directly to Jesus' right. As a consequence, it is not surprising that prayers to Mary supplement the Hours of the Virgin in nearly all late medieval books of hours. The two most frequently encountered ones are known from their opening words as the *Obsecro te* (I beseech you) and *O intemerata* (O Immaculate [Virgin]).

In the Getty Museum manuscript, the former prayer follows the abbreviated Passion Passage from John [FIGURE 6]. The text beneath the miniature contains the first part of the initial petition: "I beseech you, Mary, holy lady, Mother of God, most full of pity. . . ." Both the *Obsecro te* and the unillustrated *O intemerata* in the Spitz Hours contain a handful of nouns and pronouns that identify the gender of the supplicant. These suggest that the manuscript was made for a man, a conclusion reinforced by the preponderance of male saints among both the illuminated and the unilluminated suffrages, or petitions to the saints, to which we will shortly turn [FIGURES 7–10].

In the Song of Songs (4:12), Solomon, who ruled as king of Israel ten centuries before the coming of Christ, declares that "my sister, my bride, is a garden enclosed." Medieval Christian interpreters identified the bride with the Virgin, who was both the mother and, in her role as the embodiment of the Church, the bride of Christ. In the years around 1400, northern European artists began visually to allude to the identification of the Virgin with the enclosed garden of the Song of Songs by rendering Mary and the infant Jesus in just such a verdant space.

In the miniature by the Spitz Master that prefaces the *Obsecro te*, the seated Mother exchanges a tender glance with the Child in her lap. The Virgin's crown refers to her role as Queen of Heaven. To either side of the throne stand potted flowering plants. While the blossoms on the Virgin's left side are difficult to identify, those on her right side appear to be white lilies, which routinely appear in late medieval representations of the Annunciation as allusions to the Virgin's chastity [FIGURE 11]. A light dusting of flowering plants and two symmetrically placed trees enliven the carpet of greenery behind the throne. Although no wall or bower encloses the setting, the space is implicitly enclosed by the even scattering of flowering stalks that hang weightlessly in the sky beyond. That expanse, which comprises fully half of the miniature's height, is crowned by two angels who burst in half-length from a cloud to chant the text on the unfurled scroll in their hands.

The two do not sing a cappella, however, for they are accompanied by the four angels who play musical instruments in the enclosing borders. A harp is plucked, a stringed instrument is bowed, and bagpipes are inflated and fingered by the three angels in the outer border; the fourth angel, at the top of

13

the inner border, simultaneously blows a horn and strikes a drum. At the bottom of the inner border, a fifth angel solicits the Child's attention by pulling the cord of a whirligig.

The Virgin was not the only heavenly personage who could intercede for individual souls at the Last Judgment; the saints of Christendom could do so as well. As a consequence, suffrages, or supplications, to individual martyrs (men who died for the faith), confessors (men who professed but did not perish for the faith), and virgins (female martyrs and confessors) are a standard component of medieval books of hours. In our manuscript, only those addressed to the martyrs Christopher and Catherine are prefaced by miniatures [FIGURES 7–8]. Small historiated initials introduce the suffrages to two other saints: the martyr Sebastian (died ca. 290), tied to a tree and shot full of arrows at the order of the Roman emperor Diocletian, and the confessor Anthony Abbot (died ca. 356), the patriarch of all monks [FIGURES 9–10]. The ring of flames that encircles the latter figure refers to Saint Anthony's fire, an inflammatory skin condition against which the saint was invoked in the Middle Ages.

Although his feast day on July 25 was removed from the Roman Catholic calendar in 1969, the martyr Christopher—literally "Christ Bearer"—was and remains one of the most universally popular of saints and the especial patron of travelers. According to legend, Christopher was a Canaanite some twelve feet tall who decided to make himself the servant of the king whom he believed to be the world's greatest ruler. When Christopher caught his master making the sign of the cross upon hearing the court jester sing of the devil, however, the giant concluded that Satan must in fact be the world's greatest ruler and so became his servant instead. But when Christopher then saw his new master balk at the sight of a roadside cross, the giant realized that Christ must be the world's greatest ruler and therefore decided to seek him out.

A devout hermit advised Christopher to serve Christ by ferrying travelers across a treacherous stretch of river. One day a small child asked to be carried over. As the giant traversed the water, he found the infant weighing more and more heavily down on him, indeed so much so that he feared they both would founder. When the other shore was reached, Christopher acknowledged his moment of panic to his passenger, who in turn revealed himself to be Christ, bearing the weight of the world on his shoulders. To prove his claim, the Child told the giant to plant his staff in the ground outside his hut. The next day Christopher found it bearing the leaves and fruit of the palm tree, an allusion to the palm of martyrdom that the giant would eventually earn.

In the miniature by the Spitz Master that introduces the suffrage to Saint Christopher [FIGURE 7], we see the saint ferrying the Child across a rather unthreatening body of water. Because Christopher is a giant, the shoals reach

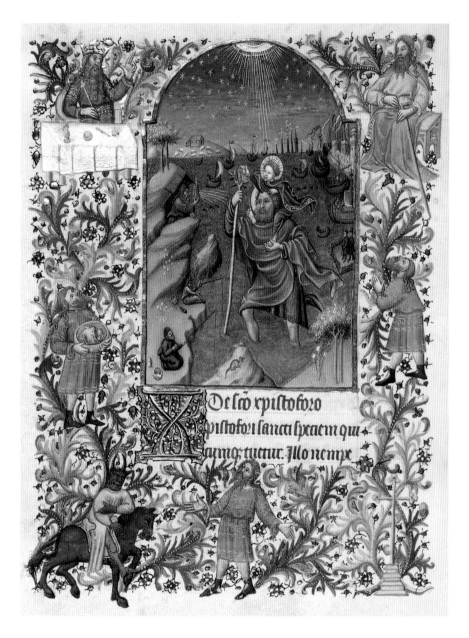

only to his calves; tellingly, his staff has already put out leaves. On the right bank, ships are clustered near the walls of a citadel and travelers stand on a jetty as they await their turn to be carried over to the other bank. There two men try their luck with fishing rods, and the hermit who had advised Christopher opens a lantern to illuminate the giant and the Savior.

Figure 7
Spitz Master, *Saint Christopher Carrying the Christ Child.* Spitz Hours, fol. 42v.

In the outer border, the servant Christopher looks up to see his first master seated at table saluting Christ—and thereby tacitly acknowledging his Christian faith—by mirroring the Child's blessing gesture in the adjacent miniature. In the lower border, the puzzled giant asks with outstretched hands why his horned second master lolls his tongue and hesitates to pass the roadside cross. In the inner border, we see Christopher twice: above, seated with the staff that he will shortly plant in the ground, and below, imitating his first master by acknowledging with folded hands the True Master he carries on his shoulders in the miniature.

Like that of Saint Christopher, the cult of Catherine was suppressed and her feast—formerly on November 25—removed from the Roman Catholic calendar in 1969. The daughter of one King Costus and a resident of Alexandria in Lower Egypt, Catherine revealed her faith to the early-fourth-century pagan Roman emperor Maxentius when she rebuked him for forcing the Christians of the city to offer sacrifice to idols. Besotted by the princess's chaste beauty but intimidated by her wisdom, Maxentius sent for fifty pagan wise men to refute her. When they were unable to do so, all fifty were converted to Christ, at which point the emperor had them burned alive.

Returning his attention to Catherine, Maxentius offered to make her second only to the empress and to make the populace worship her like a goddess if she would only renounce the faith. When Catherine rejected his enticements, Maxentius ordered the princess cast into prison and starved for twelve days. The emperor then left Alexandria to attend to affairs of state. Immediately upon his departure, the empress and Porphyrius, captain of the guard, hastened to Catherine's cell, where they found her being tended by angels. There the empress, Porphyrius, and two hundred soldiers were converted to Christ by Catherine's preaching.

Finding the princess's will still unbroken upon his return, the infuriated Maxentius ordered that Catherine be torn to shreds between wheels studded with nails and serrated teeth. Once set in motion, however, the wheels burst asunder and spewed debris that killed four thousand pagan bystanders. Now utterly exasperated, Maxentius had Catherine beheaded, a conclusion that earned her the crown of martyrdom.

On the first page of the suffrage to Catherine, the Spitz Master presents the first of four episodes from her passion in the outer border, where we see the seated princess discoursing from an open book on a lectern [FIGURE 8]. Just beneath her, two seated pagan rhetoricians marvel at her wisdom. In the miniature itself, the empress and Porphyrius, the latter holding the key to Catherine's cell, look through the open doorway in amazement to witness the partly nude princess being tenderly salved by three angels. If the crowned older man conferring intently with another man just behind Porphyrius is Maxentius, as

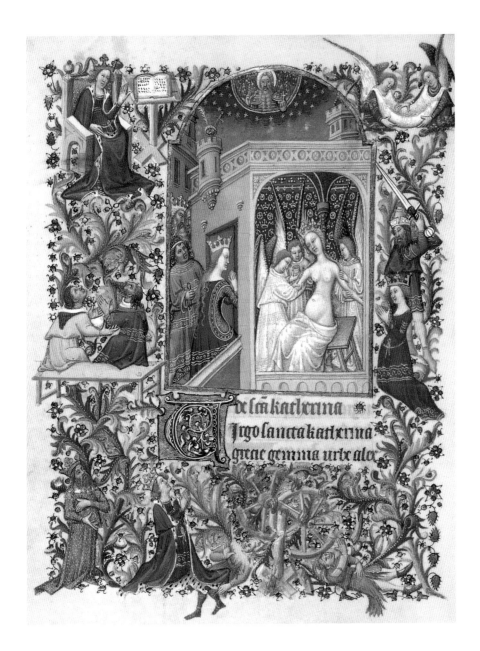

seems most likely, it suggests that the empress and Porphyrius could not even wait for Maxentius to leave town before ushering themselves into Catherine's presence. Over the doorway through which the empress passes is an oriel surmounted by three objects rendered in gold that allude to the saint's eventual martyrdom: a wheel, a sword, and a palm frond.

Figure 8

Spitz Master, *Saint Catherine Tended by Angels*. Spitz Hours, fol. 45v.

17

Figure 9
Master of the Hours of
François de Guise, Initial
S with *The Martyrdom
of Saint Sebastian.*
Spitz Hours, fol. 48v.

Figure 10
Master of the Hours
of François de Guise,
Initial V with *Saint
Anthony Abbot.* Spitz
Hours, fol. 49.

Figure 11
Spitz Master, *The
Annunciation.*
Spitz Hours, fol. 50.

In the lower border, the standing Maxentius and the kneeling Catherine look heavenward just as the flaming wheels come apart, toppling two pagans in the process. The bright red acanthus stalks next to and behind the two wheels amplify the impression of imminent conflagration. In the inner border, the princess awaits the fall of the executioner's sword; above them, two angels hold a cloth to receive Catherine's soul and hurry it to its heavenly reward.

The central text of the medieval book of hours, the Hours of the Virgin, was most often illustrated with standard cycles of eight chronologically ordered events from the life of Mary, eight similarly ordered episodes from Christ's Passion, or both. Given the French preference for infancy scenes and the wealth of Passion depictions elsewhere in the manuscript [FIGURES 2, 3, 5, 20–22, and 24], it is hardly surprising that the former introduce the Hours of the Virgin in the Spitz Hours. Only seven of the eight miniatures remain, however; the leaf with the illumination at the Hour of Sext has been removed and is lost.

Matins of the Hours of the Virgin is prefaced in the Getty manuscript by the usual subject of the Annunciation [FIGURE 11]. Luke provides us with the fullest description of the conception of Christ and of the subsequent events of his infancy. In chapter 1 (26–38), the evangelist wrote that God sent the archangel Gabriel to Nazareth in Galilee to visit Mary, a maiden betrothed to one Joseph.

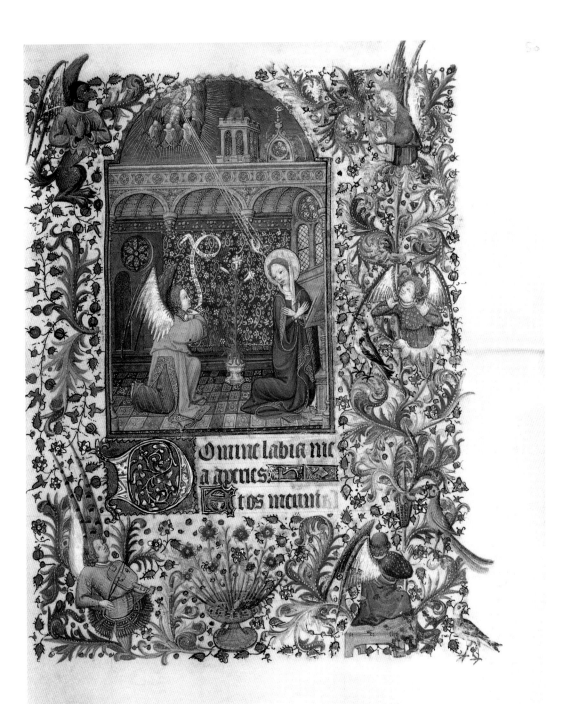

A carpenter by trade, Joseph was a native of Bethlehem and a direct descendant of David, the second king of Israel. When Gabriel informed the Virgin that she was to bear the son of God, she asked how this could be possible when she was still intact. Gabriel responded that "the Holy Ghost shall come upon you." Hearing this, the Virgin accepted her role as the bearer of the Savior with the words "Behold the handmaid of the Lord; be it done to me according to your word."

In the rendition by the Spitz Master, Gabriel genuflects before the kneeling Virgin, who turns with hands folded across her breast from the sacred text open on the lectern before her to acknowledge the archangel's presence. A vase of white lilies, symbols of Mary's purity, rests on the floor between the visitor and the visited. The meeting takes place in a loggia with a wall brocade in red, gold, and blue and with leaded-glass windows rendered in silver leaf.

Gabriel's unfolded wings and the banderole with the words "Hail Mary full [of grace] the Lord is with you" indicate that the archangel has just arrived and has just greeted the Virgin. Even as the fateful words are uttered, the Lord sends the dove of the Holy Spirit from the apex of the miniature on a fan of golden rays to impregnate his chosen vessel.

In the outer and lower borders, three angels emerge in half-length from blossoms to witness the miracle. While one expresses wonderment with raised hands, the other two pluck harps. A fourth angel in the lower right-hand corner sits on a bench and looks at the flora and birds; the most beautiful of the latter is the goldfinch next to the Virgin. Comic relief is provided by the hybrid "angel" in the upper left-hand corner with a dog's hindquarters and a skullcapped monkey's head.

When Gabriel visited Mary, the archangel told the Virgin that her elderly cousin Elizabeth, after a lifetime of barrenness, was already six months with child through God's grace. In Luke (1:39–45), we read that Mary set out shortly after Jesus' conception to the hill country of Judah to visit her kinswoman. The child that Elizabeth was carrying was Christ's precursor, John the Baptist. When the Virgin met and hailed her cousin, John the Baptist leapt in Elizabeth's womb. Filled with the Holy Spirit, Elizabeth greeted her cousin with the words "Blessed art thou among women, and blessed is the fruit of thy womb."

This event, known as the Visitation, is the subject that most often introduces the Hour of Lauds; in the Getty Museum manuscript, the subject was painted by the Master of the Harvard Hannibal [FIGURE 12]. As the two women meet, Elizabeth touches Mary's abdomen even as the Virgin reaches to touch her cousin's belly. An accompanying angel holds up the hem of Mary's overgarment together with a palm branch that alludes to the eventual martyrdom of both Christ and John.

20

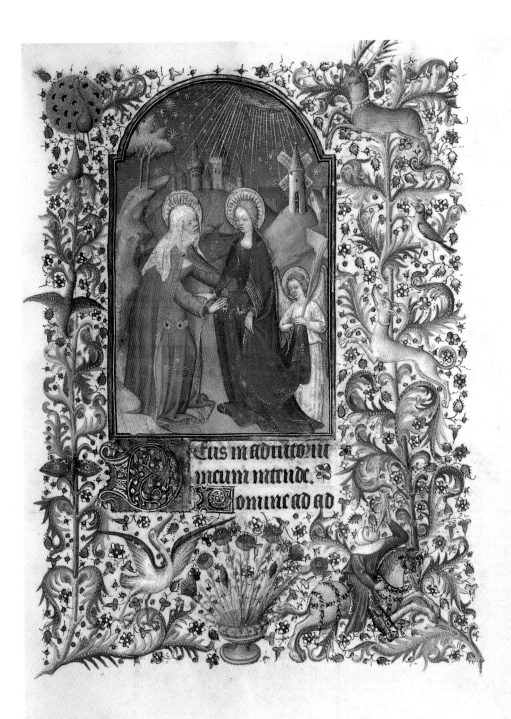

Eus in adiuto ill
meum intende.
Dominicad ad

In the outer border, a pursuit is in progress. While the border figures we have seen thus far largely complement or expand upon the events in the miniatures they surround, the characters in the borders that enclose both the Visitation and a number of other illuminations in the Getty manuscript bear no obvious relationship to the subjects they enframe. Like most medieval border characters, those in the Spitz Hours sometimes enlighten, sometimes divert, and sometimes do both. On the page with the Visitation, a hunter, riding a finely equipped steed, sounds his horn; a hunting dog above the man gives chase; and a stag at the top of the border takes flight. A peacock, a pheasant, an eye-catching red moth, and a waterfowl inhabit the inner and lower borders.

The most exhaustive description of the circumstances of Christ's birth is provided by Luke (2:1–7). To be counted for a census ordered by the Roman emperor Augustus, Joseph and the pregnant Mary had to travel from Nazareth to Bethlehem, Joseph's native city. But the poor couple, unable to find proper accommodation in Bethlehem, had to lodge in a stable, and it was there that Jesus entered the world.

The Nativity was the favored Marian episode for the Hour of Prime. In the foreground of the Spitz Master's representation in the Getty manuscript, the newborn Christ lies naked on the verdant earth between his kneeling mother and father [FIGURE 13]. While both parents fold their hands and gaze worshipfully at the infant, Jesus focuses his attention on his beloved mother. Already at birth the Savior enjoys a full head of golden brown curls and his father's dusky complexion. The vulnerable infant is encircled, cradled, and shielded by four luminous angels who surely descended to earth along the golden rays that emanate from the Lord, who appears in half-length within a ring of angels at the painting's crown. On his right side is the star that guided the magi from their lands in the east to Bethlehem (Matthew 2:2–12).

As the mattress and bolster upholstered in red that fill the stable make clear, Mary and Joseph have done a good job of making the best of their difficult housing situation. Displaced from their quarters, the ox and donkey—symbols of the Church and Synagogue, respectively—stand behind the stable and look on together with two shepherds. In the middle ground, two more shepherds warm themselves before a fire. A golden statue of an idealized nude youth commands the devotion of the two better-dressed men in the distance. The idol may represent Apollo, the ancient Greek and Roman god of light, healing, music, poetry, and prophecy. In the valley between the shepherds and the heathens is a modest townscape with blue roofs highlighted with gold. If that community is Bethlehem, then the much grander citadel partly obscured by the crest of the hill behind the two pagan worshipers must be Jerusalem.

22

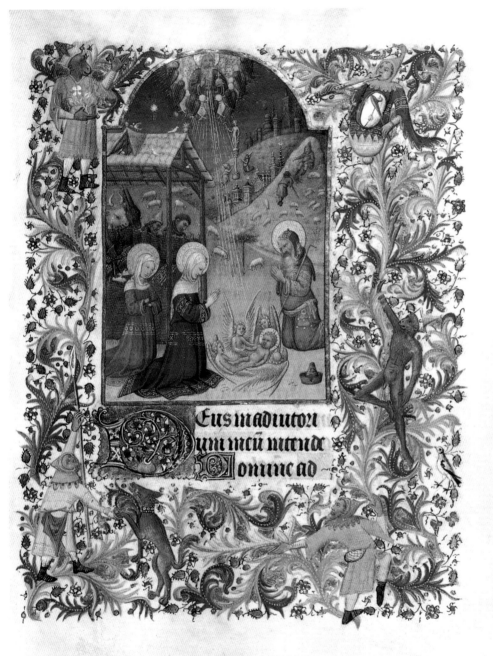

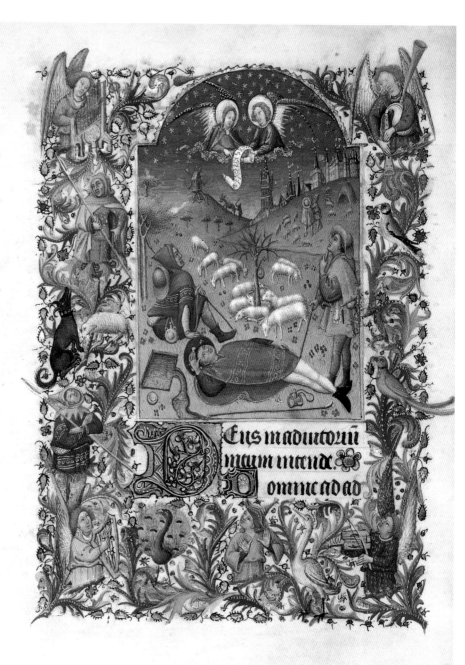

Eus madiutorui
meam intende.
Domine ad ad

The most extraordinary figure in the Getty miniature, however, is the haloed woman who kneels behind the Virgin and joins her in worshiping the Child. While the woman's forearms are brought together in a gesture of prayer, her hands are detached from her arms and held by a deep blue angel who hovers behind her. The woman is almost certainly Anastasia. Born without hands, the saint was rewarded by the Lord for assisting at the birth of Jesus with a beautiful pair of hands delivered by an angel.

Two more shepherds, their dog between them, observe the Nativity from the lower border. The shepherd at the top of the inner border presents the same simian profile as the hybrid angel in the same location on the Annunciation page [FIGURE 11]. In like manner, the richly dressed musician who emerges in half-length from a blossom at the top of the outer border to play a flute and beat a drum resembles his angelic counterpart on the page with *The Virgin and Child Enthroned* [FIGURE 6].

Luke (2:8–14) states that on the night when Jesus was born, shepherds were watching over their flock nearby. Their quiet watch was broken by the appearance in the sky of a radiant angel who informed the shepherds that the Messiah had been born in Bethlehem. At that moment the heavens filled with angels singing "Glory to God in the highest, and on earth peace to men of good will." *The Annunciation to the Shepherds* [FIGURE 14] was the usual subject for the Hours of the Virgin at Terce.

To judge from the musical notation on the scroll held by the two angels at the miniature's apex, the Spitz Master has chosen to depict the episode's most melodious moment. The two figures recall their counterparts above the artist's *Virgin and Child Enthroned* [FIGURE 6]. Bethlehem itself nestles between two staggered hillocks on the horizon. Its pink masonry walls, dark blue roof tiles, and golden weathercocks give the town a festive air; the dusky purple walls of the farthest tower are presumably meant to suggest its greater distance from the viewer. The near hillock and its scattered sheep, two startled shepherds, and portable shepherd's hut are rendered entirely in shades of green and gray. To indicate that they are the most removed from the spectator, the far hillock and the man who drives a donkey bearing a sack of grain up to the windmill on its crown are described exclusively in brown and gold.

Three more shepherds and their flock occupy the foreground. The recumbent one has just been roused from slumber by the angelic vocalists. His torso and the staff at his side parallel the miniature's lower edge; at his head is a stream rendered in silver leaf that whimsically begins or ends in a perfectly rectangular basin. A pewter drinking cup rests next to the basin, and a wooden keg is placed next to the staff. The second shepherd sits up to look at the angels; the third gazes up from a standing position, his chin resting on his staff. While

Figure 14
Spitz Master,
The Annunciation to the Shepherds.
Spitz Hours, fol. 89v.

25

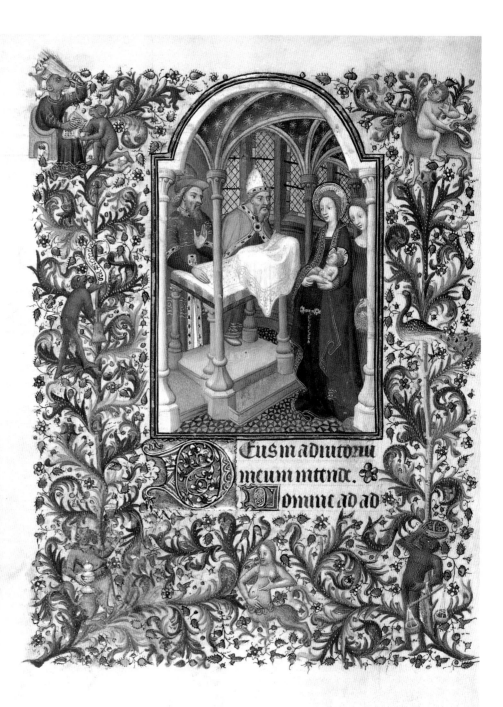

Eus madiutoriu
meum intende.
Domine ad ad

the second man's flask dangles from his waist, the third has hung his from a limb of the naked tree around which the sheep cluster.

Half-length angels playing a bagpipe, a viol, a harp, and a portative organ at the page's four corners provide accompaniment for the celestial singers in the miniature itself. Scattered in the foliage among them are three shepherds, one sheep, one sheepdog, one parrot, one waterfowl, and, in the inner border, one goldfinch that matches the one to the right of the Annunciation [FIGURE 11].

None of the Hours of the Virgin is usually introduced with an image of the Presentation in the Temple; the Master of the Harvard Hannibal painted the rendition in the Spitz Hours [FIGURE 15]. We read in Luke (2:22–24) that once the Virgin had been purified in accordance with Mosaic Law, she and Joseph brought Jesus to the Second Temple in Jerusalem in order to present him to the Lord, for the law stated that "every first-born male shall be deemed to belong to the Lord." The law also stipulated a pair of turtledoves or two young pigeons as offerings.

In a Second Temple anachronistically modeled after a Gothic chapel, Mary approaches the altar to hand Christ over to the high priest who stands behind it. The white cloth draped over the Jewish priest's outstretched hands and forearms recalls the linen with which the Christian priest holds the host during Mass and reminds the viewer that Jesus was the Living Bread. Next to the high priest is another mature man, possibly the elderly prophet Simeon; next to the Virgin is a female companion with doves or pigeons in a wicker basket. The Harvard Hannibal Master may have chosen to eliminate Joseph for the sake of compositional symmetry.

On first glance, the border figures appear to be entirely diversionary. At the top of the outer border, a simian schoolmaster prepares to thrash a wayward pupil; another monkey holds a banderole just below the pair. That this group is not to be taken entirely lightly, however, is made clear by the words *Ora pro nobis* (Pray for us) on the banderole. In late medieval art, apes were symbols of unchecked animal passions, and souls that fall prey to such desires most certainly need the healing power of prayer.

The three figures in the lower border appear to provide a more explicit warning against surrendering to baser impulses. At the left is a hybrid with leonine underparts supporting the torso, arms, and head of a portly bearded man. To the right is another hybrid with the head, arms, and torso of a nude woman, the forelegs of a chicken, and the trunk and hind legs of a lioness. While the naked woman seems to importune the man with her gaze and hand gestures, he chooses to gaze up at the more wholesome event unfolding in the miniature above. At the far right, a third monkey balances a wicker basket on its head with its right hand and holds scales in its left hand. While the basket invites compar-

Figure 15
Master of the Harvard Hannibal, *The Presentation in the Temple*. Spitz Hours, fol. 98v.

27

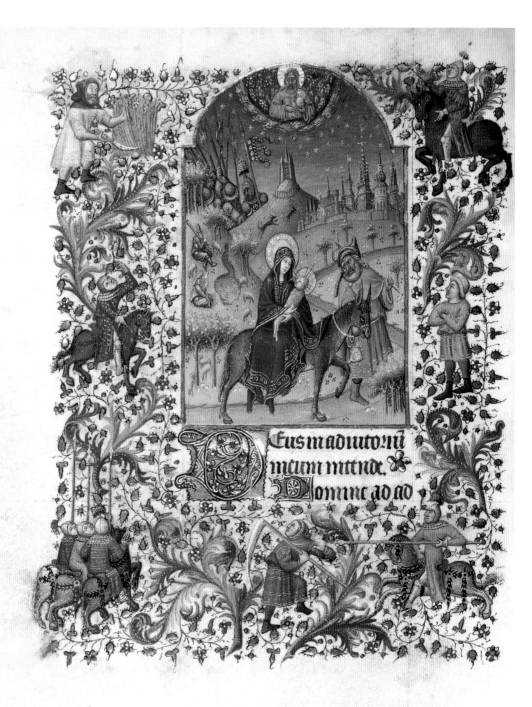

Eus m adiutorm
meum intende.
Domine ad ad

ison with the one held by the Virgin's companion in the Presentation scene, the scales remind the viewer of the weighing of souls at the Last Judgment.

At the top of the inner border, a nude youth rides bareback and backward on an ox while grasping the beast's tail as if it were a rein. In medieval art and folklore, sinners and outcasts were punished or humiliated by being made to ride animals backward. As nudity was often associated with shamelessness and unchecked passions, there is good reason to conclude that the naked Spitz youth embodies the sin of lust. But while asses, horses, goats, pigs, and even dragons were common mounts for unfortunates forced to ride backward, oxen are most unusual. In representations of the Nativity, the ox symbolizes the Church [FIGURE 13]; the ox is also the beast of Saint Luke, whose Gospel provides the only description of Christ's Presentation in the Temple. Moreover, the Spitz ox's focused attention on the momentous event rendered in the illumination has clearly drawn the youth's attention. Is the animal's example an admonition to the wayward soul on its back?

Were the miniature at Sext with the Adoration of the Magi still extant, we would have seen how the wise men from the east, drawn by the rising star that signaled the birth of the Messiah, came first to Jerusalem, where they asked King Herod the Great where they might find the Child (Matthew 2:2–12). Feeling threatened by this potential future rival, the perturbed king ascertained from his chief priests and lawyers that scripture predicted that the Messiah was to be born in Bethlehem. Accordingly, Herod sent the magi there with the request that they inform him when they had found the boy so that he too might go to Bethlehem to pay the Child homage.

After following the star to Bethlehem and honoring Jesus with gifts of gold, frankincense, and myrrh, the wise men were warned in a dream not to return to Herod, but rather to travel home another way. Shortly thereafter an angel of the Lord told Joseph in a dream to flee forthwith by night with his wife and child to Egypt to save the infant from Herod's wrath (Matthew 2:13–18). The family left just in time: upon learning that the magi had deceived him, the enraged Herod sent soldiers to Bethlehem with orders to slay all the male children under two years of age, a slaughter commemorated in the Roman Catholic calendar on December 28 as the feast of the Holy Innocents. The Flight into Egypt is the standard subject for the Hour of Vespers.

In the illumination by the Spitz Master in the Getty Museum manuscript, Joseph leads a donkey bearing the Virgin and Child in the immediate foreground in the direction of Egypt [FIGURE 16]. The Lord solicitously tracks the Holy Family's progress from the miniature's apex. A fat purse hangs from Joseph's belt, and a small water keg dangles from the walking stick over his shoulder. In the middle ground, two shepherds sit before a tiny spring that resembles a plump tadpole

Figure 16
Spitz Master, *The Flight into Egypt.*
Spitz Hours, fol. 103v.

29

more than it does a body of water. The farther figure plays bagpipes, and the nearer one spins. Although seemingly just a few yards behind the three refugees and their beast of burden, the two shepherds and the sheep scattered around them are minuscule when compared both to those figures and to the implausibly large soldiers directly behind the shepherds who approach the city of Bethlehem on the horizon at the right. These discrepancies of scale serve not only to emphasize the key players in the biblical narrative, but also to underscore the rightward progress of both the sacred figures and their malevolent pursuers.

The medieval legend of the Miracle of the Wheat Field unfolds in the borders. In the course of their flight from Bethlehem, the Holy Family came upon a farmer sowing grain. The Virgin asked the man to tell anyone inquiring after them the truth: that they had passed by just as he was seeding his field. In a trice, the sown grain grew to harvesting ripeness. Shortly thereafter Herod's men came by and asked the farmer if he had seen the Holy Family. When the farmer forthrightly replied that they had passed by just as he was sowing the field, the soldiers concluded that the man must have seen the Holy Family months before and so turned back. At the top of the outer border, the farmer prepares to harvest his miraculous grain. Soldiers on horseback converge on the man from below and from the right; a second peasant looks on from the inner border. To judge from the soldier bearing down with a spear on the scyther in the lower border, Herod's men were as ruthless as their master.

While neither the bodily assumption of the Virgin into heaven nor her coronation there as queen and bride of Christ is described in the New Testament, medieval commentators identified allusions in the Old Testament to the crowning. In the Song of Songs (4:8), for example, the lover tells the beloved that "you will be crowned." In his Psalms, David praises the Lord for having set on the king's head "a crown of precious stones" (20:4) and declares that the queen "stood on [the king's] right hand" (44:10). The first western European representations of the Coronation of the Virgin date from the twelfth century; the subject is the most frequently encountered illustration for Compline in late medieval books of hours.

The Spitz Master was responsible for *The Coronation of the Virgin* in the Getty manuscript [FIGURE 17]. There the Virgin kneels before the Lord as a red seraph descends on a blue cloud with the crown that will shortly grace Mary's head. The Virgin's throne stands ready behind her; on its seat is a tasseled cushion in purple and gold brocade that promises an eternity of comfort. Every square centimeter of the celestial throne room is upholstered with luxurious stuffs. A red and gold brocade suspended from a rod provides the backdrop; a checkered carpet of red and blue threaded with gold extends from the hem of the backdrop to the miniature's edge; a green, blue, and gold brocade covers the

Figure 17
Spitz Master, *The Coronation of the Virgin.* Spitz Hours, fol. 112.

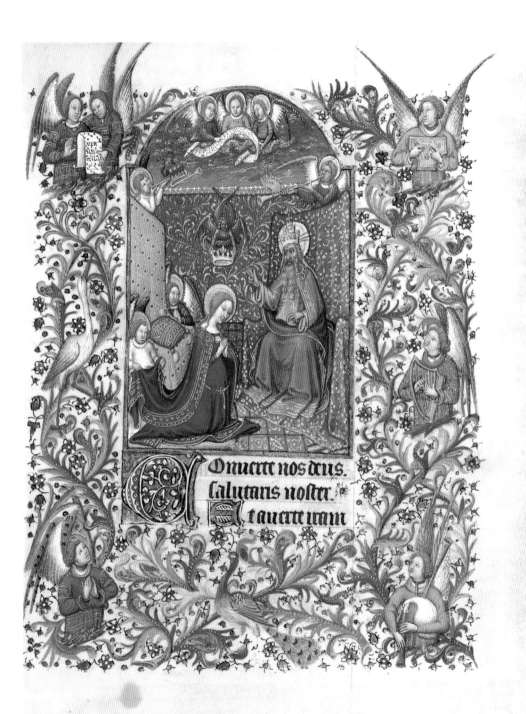

Onuerte nos deus.
Saluratis noster.
Et auerte iram

Virgin's throne; and the Lord nestles into a brocade of blue with gold and red. The resulting mosaic is one of the most dense celebrations of surface patterning in the manuscript.

An array of angels attends the scene from both within and without the illumination. An anxious one holds the train of the Virgin's cloak, an apprehensive one stands to the other side of her throne, two more-confident ones blow trumpets from behind the two thrones, and three others sing from a scroll of musical notation in the patch of blue sky seeded with golden clouds that crowns the miniature. In the inner border, two more angels sing from an unfurled banderole while a third looks up with folded hands at the coronation itself. Additional musical accompaniment is provided by the three who play a zither, a harp, and a bagpipe in the outer border.

A more modest image of the Virgin and the infant Christ in an enclosed garden fills the initial S of the *Salve regina* (Hail, O Queen), a prayer to the Virgin commonly found, as here, after the Hours of the Virgin [FIGURE 18]. In that initial, the Christ child offers to his mother some of the flowers that he and two angels have picked from the carpet of greenery beneath them. By seating the Virgin directly on the ground, the illuminator makes her a Virgin of Humility; the wicker fence that encloses the garden implicitly inscribes the central horizontal stroke of the enframing letter *S*.

Of all the books of the Old Testament, the Book of Psalms was the most important for the formation of the Christian liturgy. Ascribed to King David of Israel, its 150 songs, hymns, and prayers quickly found their way in whole or in part into the liturgies of the Mass and the Divine Office. By the sixth century, seven of the 150 (numbers 6, 31, 37, 50, 101, 129, and 142) were being recited separately by Christians to atone for their sins. It was believed that King David wrote the seven, known as the Penitential Psalms, to expiate his own transgressions, the most egregious of which was his adultery with Bathsheba and subsequent dispatching of her husband, Uriah, to certain death on the battlefield (2 Samuel 11–12).

Once Uriah was out of the picture, the king brought Bathsheba into his house, where she bore the fruit of their extramarital liaison, a son. But because what David had done was wrong in the eyes of God, the prophet Nathan was sent to inform the king that the Lord would take the child away. When the boy fell ill, David "prayed to God for the child; he fasted and went in and spent the night fasting, lying on the ground" (2 Samuel 12:15–16). But not even seven days of praying and fasting could change the will of the Lord, for the boy died just as David finished his weeklong penance.

In the Getty manuscript, the Seven Penitential Psalms are introduced by a depiction by the Spitz Master of David praying to the Lord in a landscape [FIGURE 19]. The king kneels in the foreground, his harp directly before him; the

Figure 18

Master of the Hours
of François de Guise,
Initial *S* with *The Virgin
and Child in an Enclosed
Garden*. Spitz Hours,
fol. 130.

32

Antiene de nře dame pour le samedi.

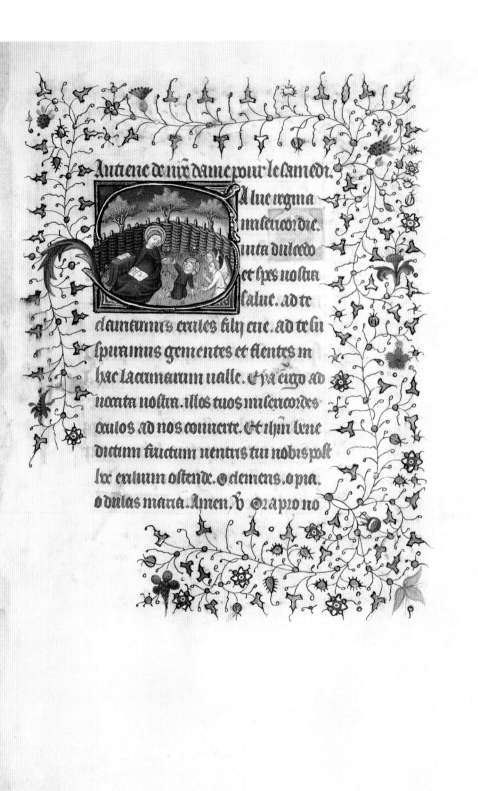

A lue regina
misericordie.
nita dulcedo
et spes nostra
salue. ad te
clamamus exules filij eue. ad te su
spiramus gementes et flentes in
hac lacrimarum ualle. Eya ergo ad
uocata nostra. illos tuos misericordes
oculos ad nos conuerte. Et ihm bene
dictum fructum uentris tui nobis post
hoc exilium ostende. O clemens. o pia.
o dulcis maria. Amen. V. Ora pro no

deity looks down at David from a glory at the top of the miniature. To judge from the rays that emanate from the Lord, the king will indeed be forgiven. The flora and fauna surrounding David indicate that he has removed himself to a rather foreboding wilderness. A tiny golden dragon, two spotted creatures that recall the European genet (*Genetta genetta*), and a member of the weasel family inhabit the dwarfish hillock just behind the king; two gargantuan snails climb up the trunks of two bonsai trees in front of him. In the middle ground, two shepherds tend their flocks next to the tadpole-shaped source of the stream that flows past David. Two rabbits and a stag are eyed by a predator that emerges from the copse on the shepherds' side of the source; a bear feeds unperturbedly on the bank on the source's other side.

The walled city of Jerusalem rises behind the two shepherds; among its many sparkling gold finials are three that anachronistically take the shape of crosses. A man hauling a sack of grain approaches the windmill that crowns the hillock beyond the water hole as three soldiers approach the Holy City. Might their number include Uriah, summoned from the Ammonite front by David after the king had violated Bathsheba (2 Samuel 11:1–15)? Or might two of the three be accompanying the messenger that Joab, David's nephew and captain, dispatched to the king to inform him of Uriah's death (2 Samuel 11:14–25)?

At the top of the inner and outer borders, a standing anthropomorphic canine and a seated simian each raise one of their legs in order to turn themselves into balancing quintains, the targets that contestants charged in the medieval sport of tilting. Beneath the two a fox or wolf carries its bloodied avian catch in its jaws and a stag stands erect on its hind legs to flute for a dancing monkey. In the bottom border, a second bird is brought down by a simian archer and an accomplice with anthropomorphic upper parts and leonine lower ones. In late medieval art, birds often represent the human soul. Are these taking of birds in the borders allusions to the Lord's determination to take David's love child, the king's performance of penance in the adjacent illumination notwithstanding?

The Agony in the Garden [FIGURE 20] and the two miniatures that follow [FIGURES 21–22] are the only illuminations in the Spitz Hours to be complemented by historiated roundels in the borders. Those three miniatures and the subsequent depiction of the Celestial Virgin and Child [FIGURE 23] are also the only illuminations that do not have to compete with contiguous texts for the viewer's attention. The three miniatures accompanied by historiated roundels—four on each page, thus twelve in toto—face a series of Passion prayers. When read in sequence, the fifteen images tell the story of Christ's final six mortal days from his entry into Jerusalem to his nailing to the cross.

The Agony in the Garden is described in the Gospels of Matthew, Mark, and Luke. After the Last Supper had been taken and the traitor Judas had

Figure 19
Spitz Master, *David in Prayer*. Spitz Hours, fol. 138.

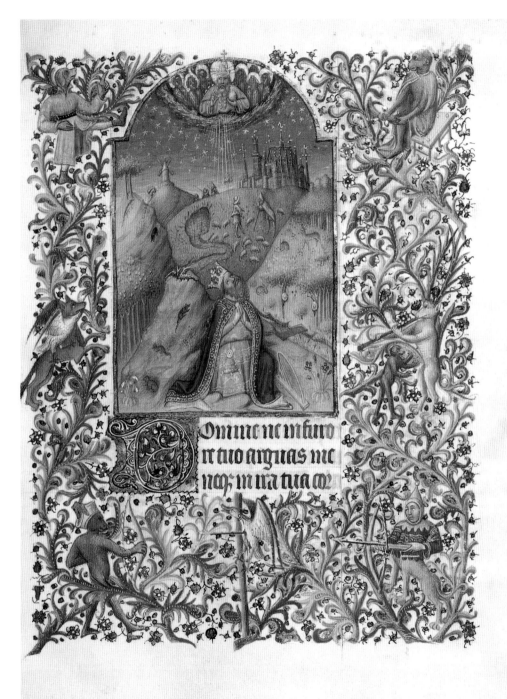

Omine ne infuro
re tuo arguas me
neqz in ira tua cor

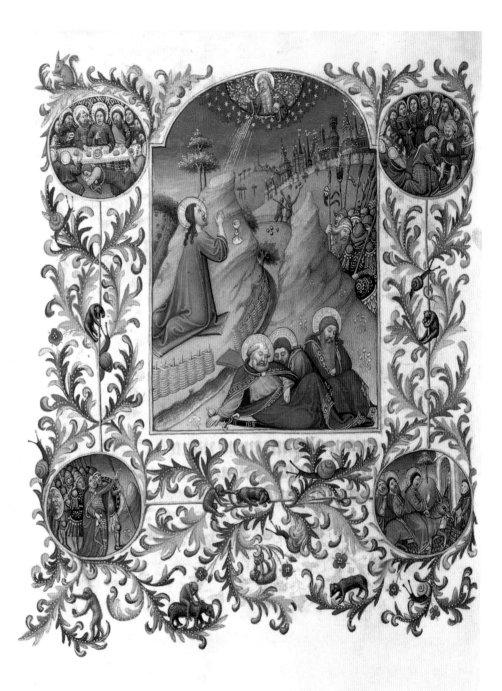

departed, Christ and his eleven remaining disciples crossed the river Cedron and entered the garden of Gethsemane. Jesus asked eight of the eleven apostles to sit while he went on into the garden to pray with Peter and the two sons of Zebedee, James and John. Overcome by anguish, Jesus acknowledged to his Father that the spirit was willing but the flesh weak, and that he would therefore gladly pass on the cup of sacrifice if it were the Lord's will. Returning to the three disciples, Christ found them asleep and berated them for their lassitude. Jesus prayed to his Father and aroused the three slumbering apostles two more times before warning all that Judas and a group of soldiers were nigh.

In the miniature by the Spitz Master, a tiny rivulet and a shin-high woven fence separate the praying Christ from his three sleeping disciples in the foreground. Jesus rests his elbows on the ledge that supports the cup of sacrifice that he would happily relinquish; the Lord addresses his Son from a glory at the top of the illumination. The soldiers sent to arrest Christ can be seen just behind the pointed outcrop that shelters the slumbering apostles. Crowning the verdant rise beyond the outcrop is the citadel of Jerusalem, its blue roofs and finials trimmed with gold and topped with golden weathercocks.

In the roundels at the illumination's corners are four earlier episodes from the story of Holy Week that must be read counterclockwise from the lower right. The first roundel contains a simplified representation of the Entry into Jerusalem, the subject of the first miniature in the Spitz Hours [FIGURE 2]. In the second, we see Christ washing his disciples' feet before they take their last meal together (John 13:3–11). While the kneeling Jesus busies himself with the nonplussed Peter, the other eleven disciples sit in a tight ring around the two as they await their individual turns.

In the third roundel, Christ blesses the meal that fills the table before him. Eleven of the apostles sit to Jesus' right and left; John, Christ's favorite, lies asleep on the floor beneath the table, his head at his master's feet. In the fourth roundel, Judas points out the praying Jesus in the large miniature to the soldiers who accompany him. As on the two miniature pages that follow [FIGURES 21–22], the four roundels are linked by three slender golden stems. These sprout parti-colored acanthus leaves that are enlivened by blossoming speedwells and inhabited by snails, apes, mammals, and birds.

Matthew, Mark, and Luke all agree that when Judas contracted to betray Jesus to his enemies for thirty pieces of silver, the turncoat told those who bribed him that he would identify his master by kissing him. When the traitor and the detachment of soldiers who accompanied him met up with Christ and his disciples in Gethsemane, Judas greeted Jesus with the appellation of rabbi and a kiss, at which moment the soldiers seized the Savior. In the ensuing commotion, Peter drew his sword and struck off the ear of Malchus, one of the high

37

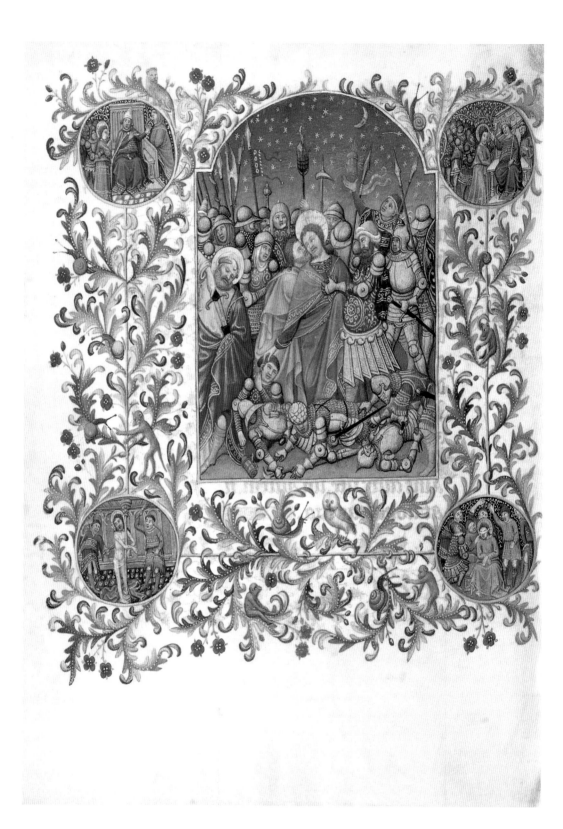

priest's servants, but Christ promptly and miraculously reattached the severed part. John, however, writes that when the turncoat and the soldiers reached the garden, the Savior went out and inquired whom they sought. When they said Jesus of Nazareth, Christ identified himself, whereupon the soldiers drew back and fell to the ground [FIGURE 21].

The Spitz Master conflates all four Gospel descriptions in his rendition of the Betrayal. Judas kisses the Savior, who reaffixes the ear of the fallen Malchus; Peter sheaths his sword; and one soldier seizes Jesus while others lie at his feet. Disoriented by the confusion of the moment, the soldiers behind the Savior turn and look in every direction. Weapons, banners, and lanterns rise above all the figures, where they are silhouetted by a blue night sky studded with golden stars and a sickle moon.

As on the preceding miniature page with *The Agony in the Garden* [FIGURE 20], the four roundels that here continue the story of the momentous events of Christ's last mortal day must be read counterclockwise from the lower right. Matthew, Mark, and Luke tell us that when the soldiers brought Jesus before Caiaphas, the high priest, on the morning after the Last Supper, Christ tacitly affirmed that he was the Son of God. In response, Caiaphas rent his garments and declared Jesus a blasphemer, whereupon the high priest's men set upon Christ, blindfolded him, and repeatedly spat into and struck his face. John once again differs, however, suggesting instead that these events transpired in the house of Annas, Caiaphas's father. Wherever it took place, Jesus' buffeting is the subject of the first roundel.

Later the same morning, Caiaphas sent Christ to Pontius Pilate, the Roman procurator (imperial agent) for the province of Judaea. Although unimpressed by the accusations that Jesus had claimed to be the King of the Jews, and thus a rebel against Roman authority, Pilate did not want more trouble in the empire's already most seditious province, and the chief priests and ancients had stirred up the mob against Jesus. According to Luke, Pilate asked if Jesus was indeed of Galilee, and upon learning that he was, hurriedly sent him off to Herod Antipas, tetrarch (subordinate ruler) of Galilee, in the hope of evading responsibility for judging Christ and thereby defusing a volatile situation. But, although Herod had long wanted to meet the man of whom so many spoke, Jesus would perform no miracles to prove himself, and so the disappointed Herod sent him back to Pontius Pilate, much to the procurator's chagrin. Christ stands before Pilate in the second roundel and before Herod in the third; both judges listen to the counsel of tonsured advisers.

As it was the Roman procurator's privilege to release one prisoner to the people at Passover, Pilate asked whom the crowd wanted set free on that occasion, Jesus or a common thief named Barabbas. When the crowd called for the robber's

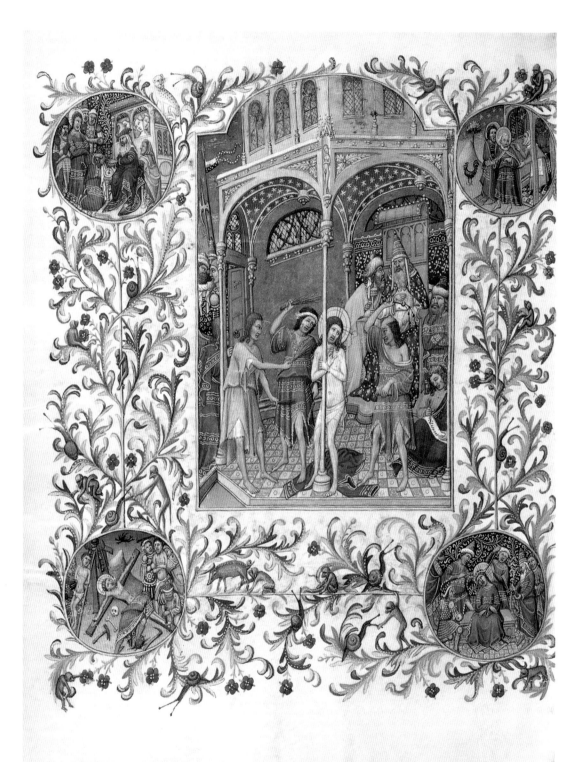

release, Pilate reluctantly sentenced Christ to crucifixion while literally and figuratively washing his hands of the affair. In order to weaken the condemned and thereby shorten his agony on the cross, the Romans routinely flogged each victim before marching him to the place of execution. This torment is the subject both of the fourth roundel and of the following large miniature [FIGURE 22].

Having been stripped and bound to a pillar with a cord at the wrists, Christ is beaten under the enthroned Pilate's watchful eye by two men wielding switches and a third armed with a cat-o'-nine-tails. With his off-the-shoulder couture and cascading shoulder-length hair beneath a bald crown, the third thug's appearance is especially disconcerting, which may be why Jesus turns in his direction and raises a hand in a futile attempt to fend him off. Is the young man seated on the floor at the far right, writing on a scroll, Pilate's scribe or John, the evangelist most often presented as an unbearded youth?

Christ's whipping is administered beneath an exquisite porch with two red vaults speckled with golden stars; surmounting it is an enclosed second story with leaded-glass windows rendered in silver leaf. The columns that support the two vaults are improbably spindly; indeed, the Savior would need only to tug sharply at the column to which he is tied to bring the whole delicate edifice down.

Of the porch's many gilded architectural details, the most interesting are the statues of a standing nude man and woman that surmount the two free-standing columns in the foreground. Both figures hide their private parts with one of their hands; are they to be identified with Adam and Eve, the First Couple, whose eating of the fruit of the tree of the knowledge of good and evil led to the Fall of Man, the original sin that Christ's sacrifice absolved?

By contrast to those on the preceding two pages, the subjects of the four roundels on this page must be read from right to left and from top to bottom, with the Flagellation itself falling between the two pairs both visually and chronologically. Thus the first subject, the Denial of Peter, appears in the upper right-hand corner.

At the Last Supper, Christ warned his disciples that all twelve would shortly abandon him to his enemies. When Peter protested loudly that he would remain steadfast, Jesus retorted that Peter would disown him three times before the cock crowed the following morning. Some eight hours later, while Jesus was being questioned in Caiaphas's or Annas's house, Peter was loitering in the courtyard without. There he was twice accused of being one of Jesus' companions, and there he twice denied it. Then other bystanders, recognizing that Peter was from Galilee, confronted him a third time, at which point he disowned Jesus with an oath. At that moment a cock crowed; in a flash Peter remembered Christ's words and burst into tears. In the roundel, we see from right to left a

Figure 22
Spitz Master, *The Flagellation of Christ.* Spitz Hours, fol. 172v.

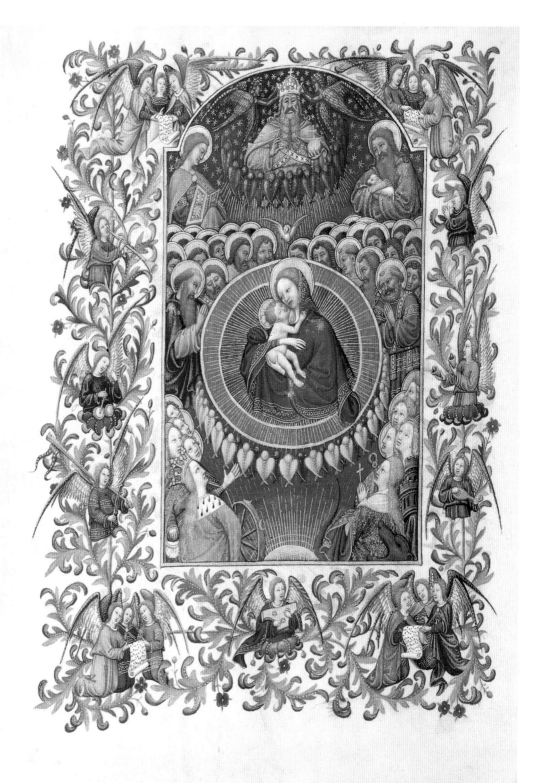

female accuser, Peter, a second apostle not mentioned in the New Testament account, and the telltale rooster.

In the second roundel, at the upper left, Pilate washes his hands as he condemns Jesus to flogging and crucifixion. After whipping Christ, which we see in the large miniature, Pilate's men enrobe Jesus, crown him with plaited thorns, put a reed in his hand, and mock his purported claim to kingship with genuflections, taunts, spittle, and physical blows. This is the subject of the roundel in the lower right-hand corner.

After trudging from Jerusalem to Calvary bearing his own cross, Christ was executed between two thieves. In the roundel in the lower left-hand corner, Jesus is shown being affixed to the cross while it still lies on the ground. Nails already perforate his hands and pull his thin arms painfully taut; an executioner drives the third nail into Jesus' feet while another thug excavates a hole to secure the foot of the cross. To Christ's either side are the thieves' crosses, which have been raised without their victims attached. As a consequence, each man must climb a single ladder to be tied or nailed to the wood. The good thief, on Jesus' right side, has already begun the ascent; a noose placed around his neck and tugged from behind assures his compliance. On Christ's left side, the clearly distraught bad thief is held fast by two men as he awaits his turn. A jet-black devil swoops through the sky in the distance, and a human femur and skull lie next to Jesus. As Adam was believed to have been buried on the site of Christ's crucifixion, the skull is surely his.

The largest miniature in the Spitz Hours faces a short prayer to the Virgin [FIGURE 23]. There Mary and Jesus are venerated in heaven by God the Father, God the Holy Spirit, and the saints. The placement of Mother and Child within a radiant aureole was probably inspired by an event described in the thirteenth-century compilation of saints' lives known as the Golden Legend. There it is related that the Roman senate wished to deify the first emperor, Augustus, while he was still on this earth. Recognizing that he was mortal, Augustus resisted this honor, but agreed to consult the sibyl, or pagan prophetess, to learn whether someone greater than he would ever be born into the world. At noon on Christmas Day, just as the sibyl consulted her oracles, a golden light encircled the sun and a glorious Virgin with the Child in her lap appeared within the fiery disk itself. Showing this to Augustus, the sibyl informed the emperor that the Infant was indeed greater than he.

The ringed glory that surrounds the Virgin and Child is positioned at the exact center of the Getty Museum miniature and is partly bordered by a tight rank of angels. By depicting the sun at the very bottom of the miniature, the artist informs the viewer that his sacred figures occupy a celestial realm above and beyond that fiery material sphere. God the Father, his flesh and hair ren-

Figure 23
Spitz Master, *The Celestial Virgin and Child*. Spitz Hours, fol. 176v.

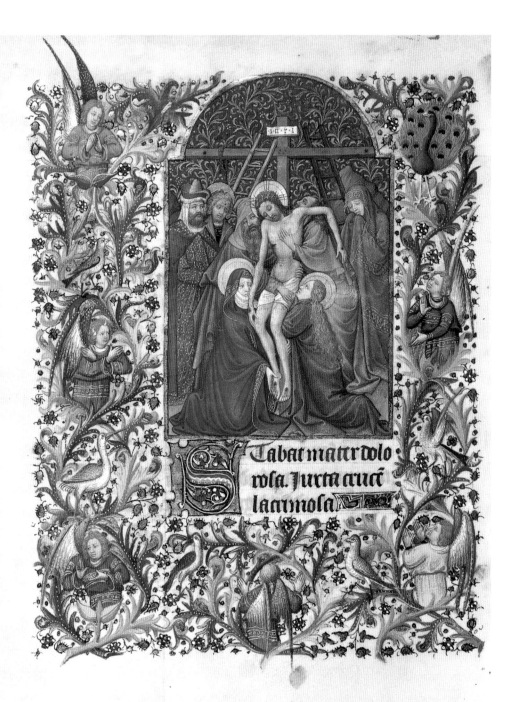

Tabat mater dolo
rosa. Jurta aucē
laaimofa

dered in matte gold, appears in half-length at the illumination's apex. Two large red angels place a crown on his head and a phalanx of smaller red angels encircles him. Next to God the Father are the two Saint Johns, the Baptist on his left and the evangelist on his right. The dove of the Holy Spirit hovers between Father and Son.

Two groups of reverent male saints surmount the glory with the Virgin and Child, and two comparable groups of female saints appear beneath it. Only the foremost two of the tightly serried men display attributes or characteristics that enable identification. To judge both from his long brown beard and from the sword handle set into the crook of his right arm, the male to the mother's and infant's right is Paul, apostle to the Gentiles; to judge from his short gray beard and tonsured gray hair, the man on their left is Peter, prince of the apostles. The prominent positions of the two provide further support for these identifications.

By contrast, at least five of the female saints can be securely identified solely on the basis of their attributes. From left to right, we see Mary Magdalene holding the flask of myrrh with which she anointed Christ's feet in the house of Simon the Pharisee (Luke 7:37–50), Catherine and the wheel with which the emperor Maxentius sought to rip her to shreds, Margaret emerging from the dragon that swallowed her in vain, Apollonia holding the pincers that crushed her teeth, and Barbara with the tower in which her father imprisoned her. A host of angels sings and plays musical instruments in the surrounding borders.

In the three miniatures and twelve accompanying roundels that precede the Celestial Virgin and Child, the Spitz Master rendered the story of Passion Week from Christ's entry into Jerusalem to his nailing to the wood [FIGURES 20–22]. All four evangelists tell us that the cross was then raised and that Jesus hung from it in agony before the multitude. Christ's public humiliation on the wood was almost certainly the subject of the excised illumination that originally introduced the Hours of the Cross; his expiration is shown in the small miniature that enriches the first Passion Passage from John [FIGURE 3]. A subsequent episode in the Passion story, the deposition of Jesus' body from the cross [FIGURE 24], prefaces the anonymous thirteenth-century hymn known from its opening words as the *Stabat Mater*. The hymn describes the Virgin's sorrows at the foot of her son's cross.

As soon as Christ had died, one of his secret followers, Joseph of Arimathaea, asked Pilate if he could take down the corpse. Upon receiving permission, Joseph removed the body with the help of another follower, Nicodemus. The two men then hastily embalmed the cadaver, wrapped it in linen, and put it into an empty nearby tomb.

In the miniature, Jesus' slumping body is gently and reverently lowered from the erect cross. Two men stand behind the corpse and grasp it at the torso

Figure 24
Spitz Master, *The Deposition*. Spitz Hours, fol. 181v.

45

Dmnclabia mea
apcgcs
Et os meum an.

and waist; two women, identified by their halos and costumes as the Virgin and Mary Magdalene, kneel to either side of the body and support the legs and buttocks, respectively. Propped against the wood are the ladders that the two men climbed to remove the nails that transfixed Christ's hands.

A third woman, presumably one of the Marys who had witnessed the crucifixion, stands to Jesus' left. Her hands, enveloped in her mantle, are raised to her chin in mourning. Two more men stand to Christ's right. The youthfulness and halo of the nearer man identify him as John, Christ's favorite disciple; to judge from his rich dress and bearded physiognomy, the farther man is Joseph of Arimathaea.

The eight figures are set very close to the viewer and very close to one another; they also fill the miniature's entire width and fully two-thirds of its height. All the actors save the largely nude Jesus wear variously colored overgarments patterned and highlighted in gold that complement the brocade of blue and gold that backdrops the scene. Thanks to this emphasis on width and height rather than depth, the illumination harmonizes especially well with the surrounding floral borders, from which six half-length angels witness the deposition and deplore Christ's death.

The Hours of the Virgin are accompanied in most late medieval books of hours by two other Hours, those of the Cross and of the Holy Spirit. Like those of the Virgin, these two Hours are read from Matins to Compline; unlike those of the Virgin, the Hours of the Cross and the Holy Spirit lack the Hour of Lauds. They also are much less prolix than the Virgin's Hours. As has already been observed, the Crucifixion that probably introduced the former text in the Spitz Hours has been excised. Fortunately, the subject that prefaces the latter text, *Pentecost*, is still intact [FIGURE 25].

In the first chapter of Acts, we read that forty days after his resurrection Jesus ascended into heaven from Mount Olivet, a promontory just outside Jerusalem. Shortly before his departure, he told his eleven remaining apostles that in a matter of days he would baptize them with the Holy Spirit, the third Person of the Holy Trinity. Upon their return to Jerusalem from Mount Olivet, the eleven elected Matthias to replace the traitor Judas. In the second chapter of Acts, we learn that the twelve apostles were assembled together on the Jewish feast of Weeks, the fiftieth day after Passover, also known by its Greek name of Pentecost. At that time a noise like a mighty rushing wind came down from the sky and filled the house. Then tongues of flame appeared and hovered over the heads of the apostles, who found themselves filled with the Holy Spirit and suddenly able to speak in the foreign languages they would need to evangelize the Gentiles.

In late medieval art, the descent of the Holy Spirit on the feast of Pentecost is usually rendered in an ecclesiastical setting. In the representation by the

Figure 25
Spitz Master, *Pentecost*.
Spitz Hours, fol. 187v.

47

Spitz Master in the Getty Museum manuscript, the miraculous event unfolds in the most expansive interior in the book, a freestanding Gothic apse of olive-green stone embellished with gold. A tapestry obscures the arcaded or enclosed ground story, arcades enliven the second story, leaded-glass windows perforate the third story, and red vaults embellished with gold stars cap the structure. Just visible to the left of the apse is a sliver of grass and sky interrupted by two Gothic buttresses.

Although the Book of Acts does not mention her presence, the Virgin is usually given pride of place among the apostles in late medieval representations of Pentecost. In the Spitz Master's rendition, she sits at the center of the composition with six apostles on either side of her. The dove of the Holy Spirit has entered the apse through the central vault boss in a spray of golden rays. Tellingly, both the Holy Spirit and the miraculous beams of light are focused on the Virgin, the earthly vessel of the Son of God and the principal devotional focus of the manuscript as a whole; presumably the golden rays will shortly fan out to touch the heads of the apostles. The reactions of the twelve range from fear to wonderment to anticipation; the three half-length angels in the surrounding borders celebrate the moment with instrumental accompaniment.

The ultimate miniature in the Getty manuscript, *A Burial*, introduces the last essential text in medieval books of hours, the Office of the Dead [FIGURE 26]. While the other texts in books of hours are quasiliturgical, the Office of the Dead is the same text that clerics recited from their breviaries or chanted from their antiphonaries. It was included in books of hours unabridged because it was thought that its recitation helped to reduce the time spent in purgatory, the place or state following death in which penitent souls were purified of sins and thereby made ready for heaven. For this reason the lay faithful read it not only at the time of a near or dear one's departure but also throughout their lives.

In the Getty manuscript, the Spitz Master illustrates the Office of the Dead with a burial. The Office has been read, the Mass for the Dead has been celebrated, and the male deceased has been transported in a coffin to the graveyard. Interment in a coffin was unusual before the late eighteenth century; once medieval burial parties reached the cemetery, the corpse was typically removed from its temporary container and placed directly into the ground. In the Getty miniature, the celebrant, having recited the Rite for Burial, sprinkles the naked body with holy water as three gravediggers work together to lower the corpse into the earth. On the ground just beyond the three lie the tools of their trade: a pickax, a hoe, and a wooden shovel shod in iron. A knot of professional mourners clad entirely in black stands next to the celebrant with bowed heads, their faces largely hidden under their cowls.

Projecting into the graveyard at a forty-five-degree angle to the viewer is an exceptionally elegant Gothic chapel constructed of pink stone. Leaded

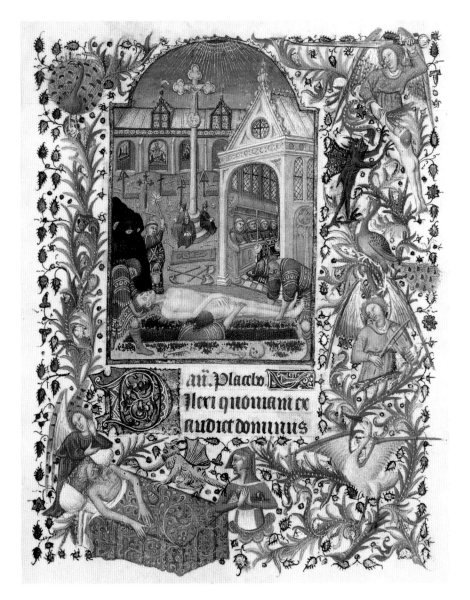

Figure 26
Spitz Master, *A Burial*.
Spitz Hours, fol. 194.

glass rendered in silver leaf illuminates the chapel and its attic, and golden flourishes edge its gable and roof ridge. Through the archway at its near end we can see a row of tonsured monks seated in choir stalls. They are reciting a text for the deceased in the coffin draped with a black pall embellished with gold that sits on the floor just before them. Because the altar is not visible, it is not clear whether the clerics are reciting the Office of the Dead or the Mass for the Dead. Given the two lighted tapers in golden candlesticks that flank the wooden box,

49

however, the latter service seems the more likely. As late medieval artists routinely depicted two consecutive events in one pictorial space, it seems most likely that the faithful departed for whom the monks pray is the same one being interred in the foreground.

The stretch of the cemetery visible behind the foreground figures and funeral chapel is peppered with gravestones, skulls, bones, and wooden cruciform grave markers painted bright red. A knight with his hands folded in prayer before his chest is carved in relief on the stone just behind the gravediggers' tools; no reliefs are visible on the farther stones. Just behind the knight's gravestone is a towering golden Calvary cross with a triple-stepped circular base that provides seating for three reading men.

The cemetery is enclosed by an arcaded cloister surmounted by a squat attic filled to capacity with skulls that face outward toward the viewer. Similar skulls crowd the dormers that punctuate the pitched roof above the attic. These macabre spectators are the remains of the graveyard's earlier occupants. As the soil of medieval cemeteries was dug and redug to accommodate new arrivals, the bones of previously interred corpses were brought to the surface. With the flesh mercifully returned to earth, the bones were collected, sorted by type, and stored in repositories known as charnel houses. Three mural or panel paintings enrich the far walls of the cloister in the miniature. While two clearly depict the Crucifixion and the Last Judgment, the great Calvary cross makes it impossible to identify the subject of the third.

If a drawing of 1552 in the Bibliothèque nationale de France is any guide, the model for the setting of the Spitz miniature was the northeastern corner of the cemetery of the Innocents in Paris [FIGURES 27–28]. Our two illustrations are lithographs published in the nineteenth century that expand on the original drawing from two different angles. The storied burial ground of the Innocents was established by King Philip Augustus of France (1180–1223) in response to the growing city's pressing need for a new site to inter its dead. Measuring hardly 80 by 100 meters altogether, the trapezoidal plot was located just 500 meters to the north of the Île de la Cité, the island in the river Seine at the heart of Paris that boasts as its crown jewel the great cathedral of Notre-Dame.

At the plot's eastern end was the modest Gothic church dedicated to the Holy Innocents that gave the burial ground its name. By the late fourteenth century, the need to store some two hundred years' worth of disinterred bones led to the building of the first charnel house along the rue aux Fers (now the rue Berger), the cemetery's northern boundary. Virtually identical ossuaries soon followed along the rue de la Lingerie and the rue de la Ferronnerie, the streets that established the graveyard's western and southern boundaries, respectively. The last charnel houses to be erected were the contiguous ones at the intersec-

tion of the rue de la Ferronnerie and the rue Saint-Denis, the latter the cemetery's eastern boundary.

The Innocents continued to accept Paris's dead until 1785, when the authorities closed and demolished it in the interest of public health. Today the site and function of the former cemetery is commemorated by the macabre Fountain of the Innocents and its surrounding square, a skateboarders' paradise that sits catercorner from the multistoried subterranean shopping mall known as the Forum des Halles.

The north, west, and south charnel houses of the Innocents and the ossuary in the Spitz illumination are strikingly similar, even to the wall buttresses that separate their cloister arcades and the skulls that bulge from their shallow attics and intermittent dormers. And although we will see in the following chapter that the chapel projecting into the Getty miniature's burial ground is based on a Parisian miniature [FIGURE 47], the structure's positioning recalls that of the porch that projected from the easternmost end of the Innocents's oldest (north) bone depository [FIGURE 27]. If the Spitz Master did have the northeastern corner of the cemetery of the Innocents in the back of his mind when he designed this miniature, then the Calvary cross that inspired him had toppled by 1552. On the other hand, the four gravestones that the artist remembered were still in situ in that year. The farthest three were not evenly spaced along a single east–west axis, however, but instead were more randomly positioned.

If the *Burial* in the Getty Museum manuscript does indeed reflect the appearance of the northeastern quadrant of the cemetery of the Innocents in Paris, then the images of the Crucifixion and the Last Judgment visible through the two uninterrupted arches of the cloister may also reflect actual wall paintings on the cloister walls of the Innocents' oldest charnel house. It is well known that a highly influential mural of the Dance of Death, the macabre cycle in which rotting corpses seize living men and women from every walk of life, was painted in the cloister of the Innocents in 1424. What is not clear, however, is whether the cycle was confined to the south cloister or spilled over into the west and north cloisters as well. If the former was in fact the case, then the Getty miniature only suggests that late-fourteenth- or early-fifteenth-century murals of the Crucifixion and the Last Judgment decorated the Innocents' north cloister. If the latter, however, then one may conclude that the manuscript was painted (or at least designed) before 1424, when the two subjects would have been replaced by episodes from the Dance of Death.

The battle over an elderly man's soul is depicted in the borders that enclose the Spitz illumination. In the lower left-hand corner, we see the graybeard on his deathbed. A fretting angel stands behind the bolster beneath his head while a grasping demon clambers onto the mattress. Emerging in half-length from a blossom at the foot of the bed is a woman—probably the man's wife or daughter—who looks on worriedly, her hands folded in prayer. The desired outcome is rendered in the upper right-hand corner. There another angel pulls the graybeard's soul heavenward with its right hand while holding a second devil at bay with the raised sword in its left. Judging from the blood pouring from a wound just above its eye, that devil had furiously resisted the positive outcome; the third angel bowing a stringed instrument in the outer border indicates that the whole drama unfolds to musical accompaniment.

The Illustrators
of the Spitz Hours

At the beginning of the preceding chapter, it was observed that the Getty manuscript's calendar includes a handful of saints especially revered in Paris and its environs. At the end of that chapter, it was suggested that the setting of *A Burial* [FIGURE 26] may be the northeastern corner of the cemetery of the Innocents in Paris. The possibility was also raised that the images of the Crucifixion and the Last Judgment visible in the churchyard cloister indicate a date before 1424 for the manuscript as a whole.

As the reader may already have gleaned from this gathering of circumstantial evidence, the illuminators of the Spitz Hours—and, indeed, of most late medieval manuscripts—neither signed their work nor indicated in what year or location they made it. Just as frustratingly, only a handful of the book painters whose names are recorded in contemporary records such as contracts, ledgers, and inventories can be connected to surviving manuscripts. As a consequence, most late medieval illuminators must be identified largely or entirely on the basis of an analysis of their style and technique. The art historian must provide these anonymous individuals with names of convenience, cautiously reconstruct their careers, and tentatively date their miniatures on the basis of comparisons with the often unsigned and undated works of other anonymous contemporaries. In this chapter, we will examine as works of art the twenty-two miniatures and three historiated initials that we considered in the preceding chapter. The analysis that follows strongly suggests that the Spitz Hours was illustrated by three anonymous illuminators in Paris in the years around 1420.

Although the miniatures in the Getty Museum book will be presented here as the work of three artists, it must be emphasized straightaway that late medieval illuminators do not conform to the romantic stereotype of the solitary inspired genius doggedly pursuing his or her artistic vision through thick and thin. Late medieval manuscripts were decorated by teams of artisans who worked in concert to produce a salable object. Each member of the team had his

or her task or tasks: ruling the page for writing; transcribing the texts in different colored inks; outlining, painting in, and gilding the decorated initials; performing the same three steps for the floral borders; composing, drawing, and painting the miniatures and historiated initials; and, lastly, sewing and binding the finished product into covers. Just as the musicians in an orchestra perform as an ensemble to produce the sound sought by their maestro, so every artisan involved in the making of a late medieval manuscript worked in concert to produce a book that met the standards and expectations established by the head of the project. Before we turn to the three illuminators of the Spitz Hours themselves, however, we must set their work into the larger context of book painting in late medieval Paris.

MANUSCRIPT ILLUMINATION IN FOURTEENTH- AND EARLY-FIFTEENTH-CENTURY PARIS

By the early thirteenth century, Paris had established itself as the leading northern European center for the making and marketing of books. The largest city in France and one of the four or five biggest in northern Europe, medieval Paris was also home from the twelfth century onward both to the largest university north of the Alps and to the French royal court and administration. Paris's commercial manuscript makers produced volumes for every purse and every taste, from modest books for impecunious students to luxuriously illuminated manuscripts for members of the royal family. Thanks to this wealth of patronage, Paris attracted northern Europe's most gifted and ambitious illuminators from the early thirteenth to the early fifteenth centuries.

In the early fourteenth century, Parisian painters routinely set their figures on shallow stages that were closed off by patterned or neutral grounds. This can be seen in *The Annunciation to the Shepherds* in the tiny book of hours painted by Jean Pucelle between 1325 and 1328 for Jeanne d'Évreux, second wife of King Charles IV of France [FIGURE 29]. There the event unfolds on a grassy mound that is just deep enough to accommodate the three shepherds, their dog, two sheep, a goat, an angel, and a tiny tree with a wonderfully serpentine trunk. A hanging of red acanthus is the backdrop for the scene.

By the end of the fourteenth century, Paris's more pioneering illuminators were seeking to expand the settings of their miniatures. Around 1385, some sixty years after the making of the Hours of Jeanne d'Évreux, the senior master Jean Le Noir began and the much younger painter Jacquemart de Hesdin completed *The Annunciation to the Shepherds* in a book of hours now known as the *Petites Heures*, or Little Hours, of John, duke of Berry [FIGURE 30]. John was the

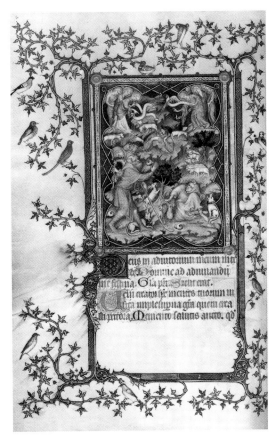

bibliomaniac younger brother of King Charles V of France and the most important patron of the book arts in Paris in the late fourteenth and early fifteenth centuries. By building his rocky setting sharply upward, Le Noir was able to provide perches for two sheepdogs, two trees, six angels, and a multitude of sheep; an acanthus pattern still closes off the background.

The greater spatial sophistication of the mature Jacquemart de Hesdin is evident in his *Annunciation to the Shepherds* in a much larger book of hours of around 1400 in Brussels [FIGURE 31]. As the arms and devices in the barbed quatrefoils encircling the miniature make clear, that manuscript was also made for John of Berry; it has been identified with the *Très Belles Heures* (Very Beautiful Hours) in the ducal inventory of 1402. While Jean Le Noir's actors in the *Petites Heures* are crowded into a tall and relatively shallow foreground space, Jacquemart's three shepherds occupy a more spacious and plausible landscape with a rocky outcrop in the immediate foreground, a pasture with a wattle fence

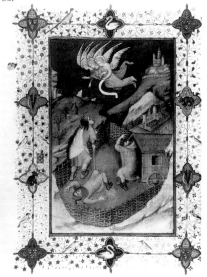

Figure 31
Jacquemart de Hesdin
(French, act. 1380–
1411), *The Annunciation
to the Shepherds. Très
Belles Heures*, Paris,
ca. 1400. Tempera and
gold on parchment, 276
leaves, 27.5 × 18.5 cm
(10 7/8 × 7 1/4 in.).
Brussels, Bibliothèque
royale de Belgique,
Ms. 11060-61, p. 82.

Figure 32
Boucicaut Master
(French, act. ca. 1400–
ca. 1420), *The Visitation*.
Boucicaut Hours, Paris,
ca. 1410. Tempera
and gold on parchment,
242 leaves, 27.4 ×
19 cm (10 3/4 × 7 1/2 in.).
Paris, Institut de France,
Musée Jacquemart-
André, Ms. 2, fol. 65v.

enclosing the shepherds and their wheeled hut just behind the outcrop, and hillocks crowned with tiny trees and miniature townscapes beneath an opaque blue firmament.

Two groups of Parisian illuminators spearheaded the effort to master actual appearances in the first two decades of the fifteenth century: the Boucicaut Master and his atelier and the Limbourg brothers. Named after his masterpiece, an especially ambitious book of hours painted about 1410 for Jean le Meingre, Marshall of Boucicaut [FIG-URE 32], the Boucicaut Master was the most prolific producer of books of hours in Paris during this period.

A comparison between the Brussels *Annunciation to the Shepherds* and *The Visitation* in the book of hours made for the Marshall of Boucicaut will serve to demonstrate just what a difference ten years can make. The Virgin and Elizabeth meet and greet one another in the foreground clearing of a landscape panorama that recedes backward in lucid and plausible stages. A gently stirred body of water navigated by a single swan in the middle ground abuts distant rolling hills on the horizon whose animate and inanimate details are as convincingly scaled as the lone bird. By rendering those hills and elements exclusively in shades of ochre and muted green, the artist suggests that haze is reducing the polychromy at the horizon to a near monochrome, a phenomenon known as atmospheric perspective. That this was indeed the Boucicaut Master's intention is supported by the appearance of the distant sky, which graduates from a milky blue interrupted by clouds on the horizon to a deep blue enlivened with golden stars and a radiant sun at the apex.

Even more naturalistic than the work of the Boucicaut Master, however, are the latest miniatures in the last manuscript illustrated by Jean, Pol, and Herman Limbourg. Originally from the Dutch city of Nijmegen, the three brothers, known collectively as the Limbourgs, are among the very few early-fifteenth-century Parisian illuminators for whom we have both names and a body of documented work.

In 1399 at least two of the brothers, Jean and Herman, were already in Paris, where they were apprenticed

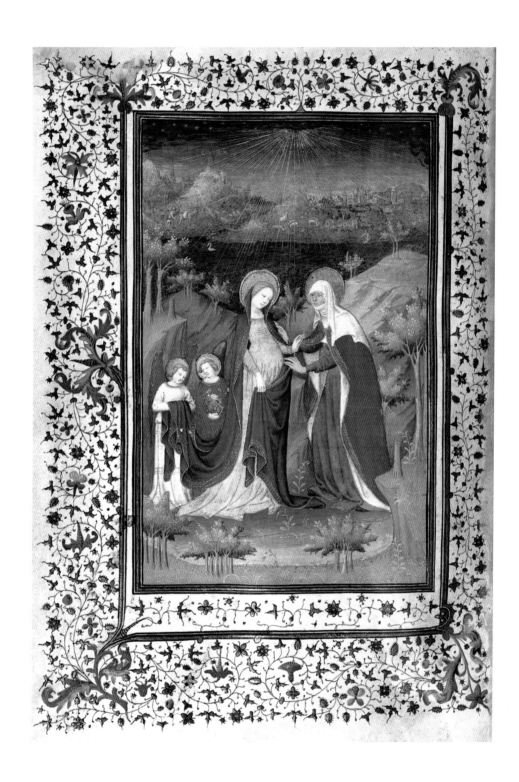

to a goldsmith by their uncle, Jean Malouel, painter to Philip the Bold, duke of Burgundy. By 1402 Jean and Pol are known to have been illuminating a manuscript for the duke. Upon Philip's death in 1404 one or more of the brothers entered the employ of Philip's brother John, duke of Berry; by 1411 all three were unquestionably working as a team for the duke. Jean, Pol, Herman, and their second great patron all died between February and October of 1416, apparently of bubonic plague.

The Limbourgs' last two great projects for John of Berry were both books of hours: the *Belles Heures* (Beautiful Hours), painted between about 1405 and 1409, and the *Très Riches Heures* (Very Rich Hours), begun around 1411 and left unfinished in 1416. Their most spacious and naturalistic miniatures are found among the partly completed group that face the calendar pages for the twelve months of the year at the beginning of the latter book; shown here is the scene of reaping grain and shearing sheep for July [FIGURE 33]. From a slightly raised and removed vantage point we view peasants at work in the shadow of one of John of Berry's favorite castles, that on the river Clain near Poitiers. Aside from the formulaic, twisted outcrops beyond the castle, the image seems almost photographic when compared to *The Visitation* painted only a handful of years before in the Boucicaut Hours.

As we will see presently, the lead artist in the Getty Museum manuscript, the Spitz Master, was directly or indirectly familiar with the work of both the Boucicaut Master and the Limbourg brothers; indeed, the Spitz Master was one of the Limbourgs' most gifted followers. We will also see, however, that the Spitz Master chose to pause on the road to the mastery of actual appearances to revisit and reaffirm the venerable medieval traditions of line, pattern, and formal repetition. It is this willful, masterful, and enchanting conservatism that makes the Getty book such an attractive and remarkable artistic and historical document.

THE SPITZ MASTER

With fully eighteen of the twenty-one large miniatures in his signature style, the Spitz Master was clearly the project director for the Getty manuscript. Although not as carefully executed as the figures in the miniatures themselves, the anthropomorphic and zoomorphic fauna in the borders enframing seventeen of the large illuminations [FIGURES 4–8, 11–17, 19, and 23–26] also appear to be the work of his team.

Active in Paris in the second and third decades of the fifteenth century, the Spitz Master has been identified as the creator of just two other manuscripts, both books of hours. While he painted all twelve of the surviving half-page

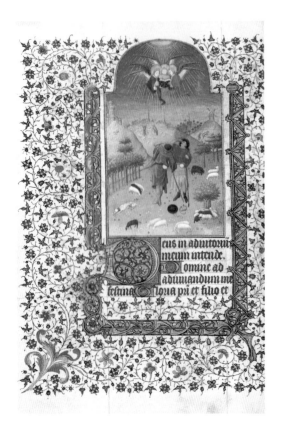 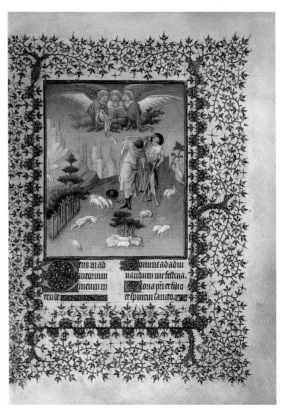

miniatures in the earlier one, now in the Musée Condé in Chantilly [FIGURES 34, 37, and 39–40], he was responsible for only six small illuminations in the later one, the Hours of Charlotte of Savoy in the Morgan Library in New York [FIGURES 54–56]. With thirteen large miniatures, nine small illuminations, and twenty-four calendar subjects, the Morgan book is the most profusely illustrated manuscript in which the Spitz Master is known to have worked; the eighteen miniatures in the Getty manuscript, however, are his greatest surviving achievements.

Although indebted to the art of the Limbourg brothers, the Spitz Master was clearly his own man, as is already evident in the twelve illuminations in the book of hours in Chantilly. While several of the compositions in the Chantilly Hours depend largely or entirely on ones developed by the Limbourgs between about 1405 and 1409 for the *Belles Heures*, a number of individual motifs in the Chantilly manuscript suggest that the Spitz Master was also aware of Limbourg inventions that found their way between around 1411 and 1416 into compositions for the *Très Riches Heures*. Given this, a date around 1415 for the Chantilly manuscript seems most plausible.

The Annunciation to the Shepherds in the Chantilly Hours is especially close to the miniature of the same subject in the *Belles Heures* [FIGURES 34–35]. Common to both are the two standing shepherds, one with his wide-brimmed black hat on the ground; the trio of half-length singing angels who hover in the sky above the astonished men; the cluster of sheep that slumber under a foreground copse of dwarfish trees; the lean hunting dog that rests at the left before a row of comparably tiny trees surmounted by a lone large one; and the outcrop beyond the row of trees crowned by a partly visible cityscape. To judge from the different colors of the garments in the Spitz Master's and Limbourgs' depictions, the former artist was working from a drawn rather than a painted model.

The Spitz Master was evidently dissatisfied with the shallow setting in the *Belles Heures*, however, for he inserted three staggered hillocks beyond the Limbourgs' foreground rise. Two more standing shepherds and their ample flock occupy the middle one; a ring of trees encircles the second hillock; and a man drives a donkey burdened with sacks of grain to the windmill at the apex of the third. Both the insertion of the distant pair of shepherds and their flock and the scattering of black sheep among the otherwise snow-white herd in the foreground recall in a general way similar details in the same subject in the *Très Riches Heures* [FIGURE 36].

On the other hand, the muted olive greens and browns used to render the distant elements in the Getty *Annunciation to the Shepherds* and the graduated blue sky and radiant golden sun that surmount them invite comparison with the same features in *The Visitation* in the Boucicaut Hours [FIGURE 32]. The border foliage on this and the other eleven illuminated Chantilly pages also resembles that of the Boucicaut manuscript. In both books, the dominant forms are undulating tendrils drawn in black ink that bear golden leaves and small flowers in gold, red, and blue; these forms are known as *rinceaux*. Scattered among them are larger blossoms and sprigs of multicolored acanthus.

What distinguishes the Chantilly miniature from those in both the *Belles Heures* and Boucicaut Hours, how-

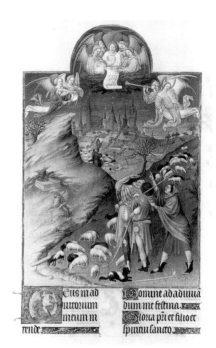

ever, is its richer decorative embellishment. White and red blossoms join the golden leaves that peer out from among the green leaves on the trees, and tiny red, blue, and white flowers pepper the verdure in the foreground. This taste for more detailed surfaces and volumes is underscored by the wide scattering of sheep and structures on the first added hillock and the belt of trees on the second.

The Chantilly *Annunciation* also depends on the Limbourg composition employed in the *Belles Heures* [FIGURES 37–38]. In both the Chantilly and Cloisters renditions, Gabriel has just crossed the threshold of Mary's private chamber to deliver the Lord's message. An exquisite construction of greenish gray masonry, the structure comprises two open arches on slender columns in the foreground, the arched threshold at the left through which the archangel entered, and a rear wall embellished with arches. With wings still partly extended outside the chamber, Gabriel genuflects in profile while pointing out the arrival of the dove of the Holy Spirit amid a spray of golden rays just above the head of the Virgin. Kneeling before her prie-dieu in three-quarter view, the Virgin acknowledges her acceptance of her role in the story of human salvation by leaning her head in the archangel's direction.

A comparison of the two miniatures also makes clear how much the masculine and feminine figure types of the Spitz Master owe to those of the Limbourgs. At the same time, the former artist's actors tend both to be slighter than those of the brothers from Nijmegen and to have larger, more heavily lidded eyes. The Spitz Master's older men also have duskier complexions than those of the mature males in the *Belles Heures*.

As he did in the Chantilly *Annunciation to the Shepherds*, however, the Spitz Master enriched his Annunciation with additional narrative and decorative details. First, the oblong format of the Chantilly illumination has enabled him to depict both the roof of Mary's oratory and a tall structure resembling a bell tower just beyond it. Second, the artist has included a narrow strip of landscape to the left of the oratory. We thus learn that Gabriel flew in a direct line from the Lord to the Virgin without having to pass anticlimactically through one or more enclosed spaces. The tadpole-shaped body of water just behind the archangel's right foot is especially characteristic of the artist; similar ones appear in the Getty Museum manuscript's *Flight into Egypt* [FIGURE 16] and *David in Prayer* [FIGURE 19].

Burnished gold is used to describe the ribs and ridge embellishments of the roof of the Chantilly oratory and the clouds that seed the blue sky at the miniature's apex. The monochromatic barrel vault in the Limbourgs' oratory has been replaced by two bright red vaults with golden ribs; just as emphatically

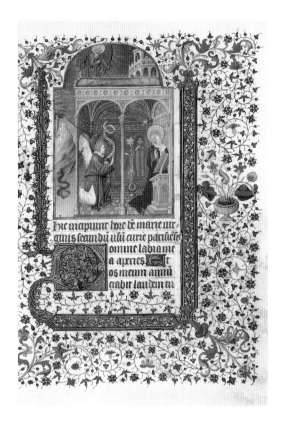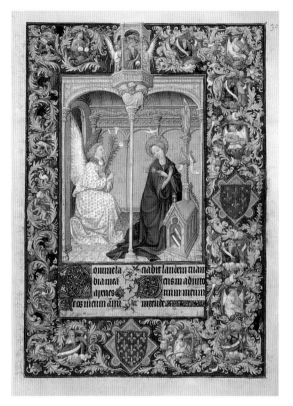

Gothic in style are the embellishments inside the arches at ground level. Gold is used unstintingly to enliven the decorative patterns above the arches of the oratory; the doughnut-shaped vessel that holds the towering white lilies on the richly tiled floor is both gloriously eccentric and patently unstable.

The Chantilly *Annunciation* seems positively understated, however, when compared to the same subject in the Spitz Hours [FIGURE 11]. Like that in the *Belles Heures*, the oratory in the Getty *Annunciation* is as wide as the miniature itself. Both illuminations are also encircled by borders with half-length figures surrounded by stylized acanthus fronds.

While the Virgin's crossed hands in the Getty manuscript hark back to the Limbourgs' conception, the Getty and Chantilly Gabriels both hold a banderole bearing the archangel's greeting rather than the white lilies borne by the Cloisters Gabriel. In both of the Spitz Master's renditions, the flowers have been relocated to a chalicelike vase on the floor between the two figures. Both the Getty and Cloisters oratories are barrel vaulted, but the classicizing austerity of the Cloisters setting is rejected in the Getty rendition in favor of windows in

Figure 37
Spitz Master, *The Annunciation.* Book of hours, fol. 28 (see Figure 34). © Réunion des Musées Nationaux / Art Resource, New York. Photo: R. G. Ojeda.

Figure 38
Limbourg Brothers, *The Annunciation. Belles Heures,* fol. 30 (see Figure 35).

the Gothic style that recall the similarly decorated arches at ground level in the Chantilly *Annunciation*. The barrel-vaulted structure that rises above and behind the Spitz Hours oratory supports a Gothic arch rimmed with floral decoration and topped by a finial.

What is most striking about *The Annunciation* in the Getty Museum book, however, is its even more dazzling polychromy and insistent patterning. While the pale green stonework of the Chantilly oratory is embellished with gold and crowned with red vaults, the unpainted wooden planks of the Spitz Hours vault are striped with red arches, and the wall beneath it is hung with a lavish red and gold brocade that entirely overshadows the gold highlights on the green stonework. In addition, the structures that rise above the Getty oratory combine pink and green masonry, green and olive roofs, silver-leaf windowpanes, and gold highlights to create a truly fantastic urbanscape.

This decorative tour de force is perfectly complemented by the dense borders enclosing that miniature and fifteen of the sixteen others in the Spitz Hours that surmount lines of text. On those sixteen pages, the *rinceaux* and blossoms that predominate on the page with *The Virgin and Child Enthroned* [FIGURE 6] are reduced to filling the interstices between spikier multicolored acanthus leaves and stems, birds, flowering plants, and the figural decoration by the Spitz Master's team described in the preceding chapter. On the pages with *The Virgin and Child Enthroned*, *The Annunciation*, and several other subjects, the border figures serve further to bind the miniatures and borders together iconographically.

The most important consequence of the emphasis in the Spitz Hours on surface embellishment is the way that it influences the viewer's first impression of the entire page. On the page in the Chantilly manuscript with *The Annunciation*, the six lines of text and entirely floral border establish a two-dimensional enframement for an event that seems to occur in three dimensions behind and beyond the sheet of parchment. Thanks to the opaque blue ground that defines the border and the gold leaf that foils the half-length figures in the miniature, the contrast between the shallow borders and the deep stage upon which the Cloisters *Annunciation* takes place is even more marked. In the Getty Museum *Annunciation*, however, the comparably dense patterning in both the miniature and the enclosing border gives the page an overall decorative unity that encourages the spectator to read it first and foremost as an interlocking web of surface patterns.

That the Spitz Master was already moving toward a privileging of surface patterning over the illusion of depth when he painted the Chantilly Hours is made clear by the depiction there of the Virgin and Child in an enclosed garden [FIGURE 39]. There Mother and Child sit on an embankment of red brick.

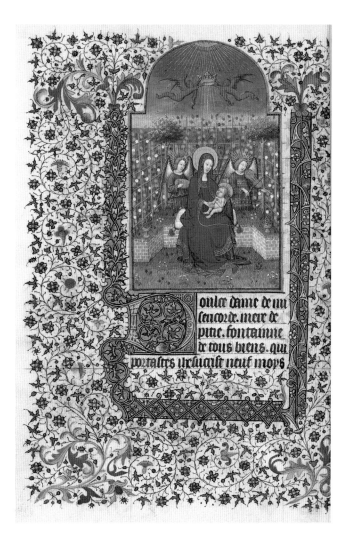

They are flanked by two potted flowering plants, two small trees, and two angels who stand just beyond the embankment and play stringed musical instruments. Gold leaves and red blossoms dot the trees, and white and red flowers spangle the greenery that crowns the embankment and carpets the ground beneath the Virgin's feet. Behind the angels and the embankment is a trellis that provides a ladder for climbing plants speckled with red and white blossoms. The trellis and the flora that exploit it not only enclose the garden, they also effectively wall off the composition to two-thirds of its height. In the top third of the miniature, two wispy angels descend with a crown against a hazy blue sky; a radiant sun fills the miniature's apex.

Figure 39
Spitz Master, *The Virgin and Child in an Enclosed Garden*. Book of hours, fol. 142v (see Figure 34). © Réunion des Musées Nationaux/ Art Resource, New York. Photo: R. G. Ojeda.

While the shallow garden and its rich and even patterning of flowers complement perfectly the enclosing border foliage on the Chantilly page, the firmament above the trellis still provides an egress. No such exit compromises the analogous miniature in the Spitz Hours [FIGURE 6]. There the even scattering of flowering plants that hangs in the sky fully encloses the composition like a miraculous, gravity-defying tapestry that subtly complements the carpet of *rinceaux* in the borders. The four music-making angels accommodated among the *rinceaux* are presumably within hearing range of Mary and Jesus; to judge from the fifth angel with the whirligig, all seven figures are in the same visual plane as well.

The greater emphasis in the Getty illuminations on compositional density, copious patterning, and exuberant polychromy can also be seen by comparing the Getty and Chantilly Coronations of the Virgin [FIGURES 17 and 40]. Both compositions recall those of Coronations painted in the second decade of the fifteenth century by the Boucicaut Master and his workshop; the example reproduced here is found in a book of hours of about 1415 in the Getty Museum [FIGURE 41].

In that rendition and in the Chantilly and Getty Coronations, the Virgin kneels before the enthroned Lord as an angel or angels descend with a crown to place on her head. Behind the Virgin are two standing angels and her waiting throne, which, like that accommodating the Lord, is set at a forty-five-degree angle to the viewer and is draped with brocade. A gold-threaded cloth of honor hangs behind the Chantilly and Getty figures; a diapered ground closes off the Boucicaut Master's representation.

Once again, however, the differences between the Chantilly and Getty images are much more striking than their similarities. The most obvious of these is the full lunette of blue sky densely seeded with golden clouds that in the Getty Museum miniature replaces the architectural superstructure behind the Chantilly cloth of honor. While scattered clouds enrich a handful of skies in the Chantilly manuscript [FIGURES 34 and 37], no Chantilly sky is as densely clouded as the Getty sky. It is even more telling that not a single firmament in the Chantilly book is strewn with the golden stars that speckle so many of the skies in the Spitz Hours.

More important than the redesigned apexes or differing numbers and positions of angels in the two Coronations, however, are the brighter polychromy and more assertive patterning in the Getty representation. Deep blue, light and dark green, salmon red, and reddish orange are the dominant colors in the Chantilly Coronation. The blue and dark green worn by the angels who usher the crown downward toward the Virgin's head match the blue of the Virgin's garment and the green of her throne brocade. Purplish blue and pale

pink stuffs offer quiet contrasts to this harmonious and understated color scheme, one that the gold and white used to pattern the brocades do nothing to challenge.

But while both throne brocades are green in the Chantilly rendition, the Virgin's is green and the Lord's a rich purplish blue in the Getty version. The placement of a cushion in the same purplish blue on the Virgin's empty seat and the denser gold patterning of both stuffs serve to make the patterns and polychromy even more insistent. Further enlivening those throne draperies are the blue disks on the Virgin's green one, the red petals on the Lord's purplish blue one, and the red tassel knots on the Virgin's purplish blue seat cushion. Similarly, the understated black and light blue of the Chantilly floor tiles are no match for the glowing checkerboard of red and purplish blue tiles that make up the Getty floor. Finally, the shimmering gold highlights on the Lord's tunic in the Getty illumination easily outshine the gold threadings on the same figure's garment in the Chantilly miniature. The jubilant angels in the borders and the jungle of brightly colored flora that houses them help further to knit the entire page into a dazzling and unified whole.

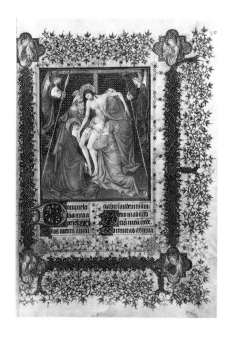

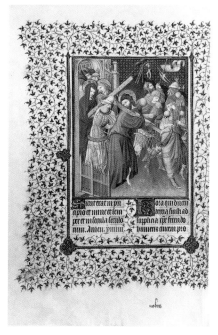

A comparable decorative integrity characterizes the Getty *Deposition* [FIGURE 24]. The most likely source for the five characters at the core of the composition is *The Deposition* in the *Belles Heures* [FIGURE 42]. Tellingly, however, the two angels who display the lance and the spear bearing the vinegar-soaked sponge in the Limbourgs' rendition are absent. In their place are three standing mourners who, together with the rocky outcrops behind the outermost two lamenters, entirely fill the lower two-thirds of the miniature.

By propping two ladders against the cross behind his seven characters, the Spitz Master is able to reinstate the inward diagonals that the lance and spear had established in the Cloisters painting. The taller format of the Getty miniature allows the Spitz Master to render the apex of Christ's cross with its identifying inscription; he also replaces the tight diapering in the Limbourgs' representation with a backdrop of undulating gold acanthus that better complements both the curvilinear gold threading on the garments of his two outermost mourners and the undulating fronds of multicolored acanthus in the borders. As on the page with the Coronation, the half-length figures in the borders—here grieving rather than rejoicing angels—serve further to relate the periphery to the center.

The liberties that the Spitz Master takes with other Limbourg models used in the *Belles Heures* demonstrate his desire to allude to other moments before and after the event rendered in the illumination itself. For *The Way to Calvary* [FIGURE 5], for example, the Spitz Master drew on a Limbourg composition that also served as a direct or indirect source for the same subject in the Cloisters book [FIGURE 43]. In the two miniatures, the Savior, his cross, the armored thugs to his either side, the soldier at the far right, the Virgin and John at the far left, and the gateway and exterior wall of Jerusalem are virtually identical. Judas can also be seen in both illuminations hanging from a tree that crowns a hillock in the distance.

Although no narrower than the version in the Cloisters Hours, the Getty composition lacks the two men who blow a horn and display a pennant at the head of the

Limbourgs' procession. At the same time, the black soldier behind Jesus, the figure of Simon of Cyrene behind the vertical beam of the cross, and the multitude of gawkers behind the Virgin and John in the Spitz Master's conception are absent from the illumination in the *Belles Heures*. By eliminating the figures in front of Jesus and crowding more of them behind him, the Spitz Master emphasizes the Savior's expulsion from the city that had embraced him only five days earlier. That Jesus is being inexorably impelled along the path leading to the fulfillment of his destiny is further underscored by the paved road—lacking in the Limbourgs' depiction—that he and the crowd tread. The instruments held by the angels in the borders remind us of the torments that both precede and follow the Savior's harrowing walk to the site of his execution.

In other miniatures in the Getty Museum manuscript, border vignettes serve as vehicles for additional storytelling. As he did with *The Way to Calvary*, the Spitz Master exploited the Limbourgs' arrangement for the Cloisters Saint Catherine in prison [FIGURE 44] for his rendition of the same subject in the Getty Museum book [FIGURE 8]. The lavish wall brocade behind the Spitz Master's saint, the richer detailing with gold of various garments and architectural elements, and the addition of the figure of Maxentius behind her visitors all underscore the more richly decorative character of the Getty conception. However, the two compositions are mirror reversed. Did the Spitz Master know at least some of the Limbourgs' design for the *Belles Heures* through tracings made from the versos either of the unbound New York miniatures or from finished shop copies after them?

In the Cloisters manuscript, Catherine's disputation with Maxentius's wise men before her incarceration, her escape from the wheel, and her final beheading are rendered in separate miniatures. In the Getty book, those three episodes are depicted in the borders that surround the depiction of Catherine's imprisonment. The manuscript's owner could thus take in at a glance a synopsis of Catherine's passion before reading the supplication to the martyr that commences beneath the miniature.

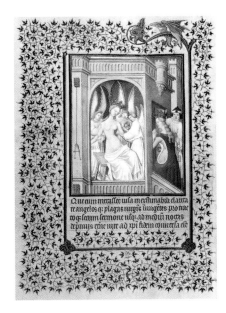

Figure 44
Limbourg Brothers,
Saint Catherine Tended by Angels, *Belles Heures*, fol. 17v (see Figure 35).

Opposite
Figure 42
Limbourg Brothers,
The Deposition.
Belles Heures, fol. 80
(see Figure 35).

Figure 43
Limbourg Brothers,
The Way to Calvary.
Belles Heures, fol. 138v
(see Figure 35).

69

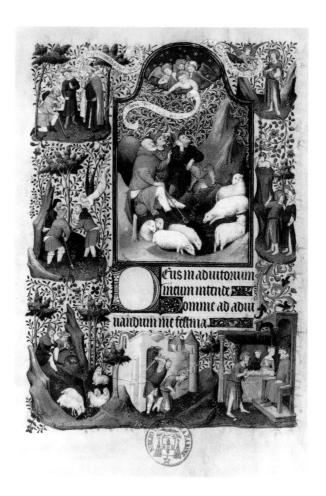

Figure 45

Master of the Mazarine
Hours (French, act.
ca. 1405–15), *The
Annunciation to
the Shepherds*. Book
of hours, Paris, ca.
1410–15. Tempera
and gold on parchment.
Paris, Bibliothèque
Mazarine, Ms. 469,
fol. 56v.

To judge from a book of hours of the early 1410s in the Bibliothèque Mazarine in Paris, it was an associate of the Boucicaut Master known after this book as the Mazarine Master who first realized the narrative potential of border vignettes. Floating in the borders surrounding the Mazarine *Annunciation to the Shepherds* [FIGURE 45] are five islands of earth or rock. The two small ones in the outer border support scenes from the story of the shepherds; the two petite ones in the inner border and the large one in the lower border present five episodes from the life of John the Baptist. In the Getty Museum manuscript's borders, the figures are nestled directly into the foliage. Both the calligraphic gold acanthus that provides a backdrop for the Mazarine miniature and the undulating plant stems in the borders establish a decorative harmony that invites comparison with the similar concord between illuminations and borders in the Spitz Master's miniatures in the Getty manuscript.

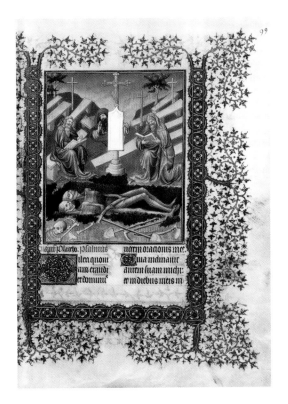

Several narrative episodes are also conflated on the Getty page with *A Burial* [FIGURE 26]. Two elements in the illumination hark back to Limbourg models employed in the *Belles Heures*. First, the three men who sit and read around a Calvary cross in the middle ground recall the two men who do likewise in the miniature that introduces the Office of the Dead in that book [FIGURE 46].

Second and more compellingly, both the Getty *Burial* and the illumination for the Mass for All Souls in the Cloisters manuscript [FIGURE 47] feature strikingly similar chapels that project into grassy turf at forty-five-degree angles. Along their far walls are canopied choir stalls with acanthus terminal flourishes that seat rows of clerics who pray for the deceased souls in the coffins flanked by lighted tapers on the floors before them. Because the Limbourgs' chapel is set in the immediate foreground, the arched opening at its near end is almost as tall as the miniature itself. By contrast, the Getty chapel's removal to the middle ground and its concomitant diminution enables the Spitz Master to include the structure's attic and roof, the latter lavishly and characteristically edged with golden Gothic decoration.

Figure 46

Limbourg Brothers, *The Office of the Dead. Belles Heures*, fol. 99 (see Figure 35).

Figure 47

Limbourg Brothers, *Monks Reciting Mass for the Dead. Belles Heures*, fol. 221 (see Figure 35).

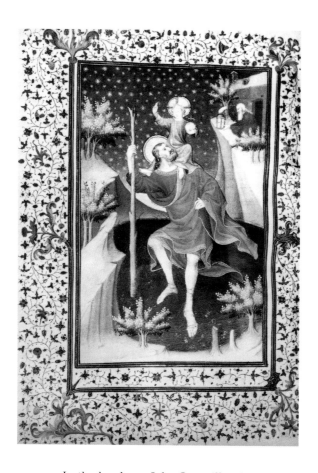

In the borders of the Getty illumination, an angel and a devil struggle over the soul of a man on his deathbed. In the miniature itself, we see two of the events that follow a Christian death, a funerary service and then interment. Given their distance from both events, the three men at the foot of the Calvary cross could be praying for any of the individuals already buried in the churchyard. The Spitz Master thus reminds the spectator of the fate of our souls' mortal vehicles from the spirit's departure from the flesh to the body's return to earth. By rendering a graybeard in the lower border and a smooth-faced younger man being lowered into the earth in the miniature, the Spitz Master underscores the fact that death may come at any point on the path of life.

A generous serving of narrative and anecdote also enriches the Getty page with *Saint Christopher Carrying the Christ Child* [FIGURE 7]. The composition as a whole recalls a number of depictions of the saint in early-fifteenth-century Parisian books of hours; reproduced here is the example in the

Boucicaut Master's name manuscript [FIGURE 48]. In both representations, the giant, striding through a body of water with Jesus on his shoulders, dominates the central vertical axis. Barren and verdant outcrops bearing petite trees flank the water. The hermit who encouraged Christopher to serve the Savior by toiling as a ferryman illuminates the figures with a lantern from the shore.

However, the Boucicaut setting seems positively threadbare when compared to the crowded and animated Getty landscape. Except for the hermit and his hut, there are no signs of human presence in the shallow Boucicaut clearing. By closing off the body of water behind the saint and his charge with an escarpment, the artist also gives the impression that the two are wading through a tiny pool rather than treacherous shoals.

By contrast, the setting in the Getty miniature is considerably more profound and enlivened by human activity. Breezes drive wavelets on the surface of the expansive body of water that Christopher negotiates; they also fill the sails of the numerous ships that ply those waters and flutter the pennants that crown both the vessels' masts and the towers of the citadel on the near shore. Delightfully, the finials topped by golden crosses and weather vanes just visible beyond the horizon suggest that the buildings beneath them are sinking into the watery depths. While Saint Christopher is appropriately a giant in both miniatures, the miniature scale of the two men waiting for passage at the jetty on the far shore and the two fishermen on the near shore in the Getty rendition remind us that the saint and his sacred burden are still the focal point of the illumination.

Three of the events that precede and succeed Saint Christopher's momentous encounter with Jesus are told in the outer and lower Getty borders. The Spitz Master's emphasis on narrative even colors his presentation of the Christ child. In the Boucicaut miniature, the infant is depicted more as a divine ruler than as a ferryman's charge. In his left hand is an orb crowned with a Greek cross, a symbol of the world and the Child's authority over it. That detail, the raising of his right hand in blessing, and the imperious gaze that he casts in the spectator's direction all remind us that Christ will come at the end of time to judge the quick and the dead, his awkward straddling of the saint's neck and shoulders in the present circumstances notwithstanding. By depicting Christopher gazing upward, the Boucicaut Master underscores the saint's recognition of the Child's divine character rather than his responsibility for seeing him safely across the water.

The Spitz Master's infant, by contrast, is clearly focused on getting to the other shore. He grips the saint's hair with his left hand and points landward with his right. Both Christopher and the Child look in the direction of the safe shore; the saint also helps to steady the precariously perched infant by grasping

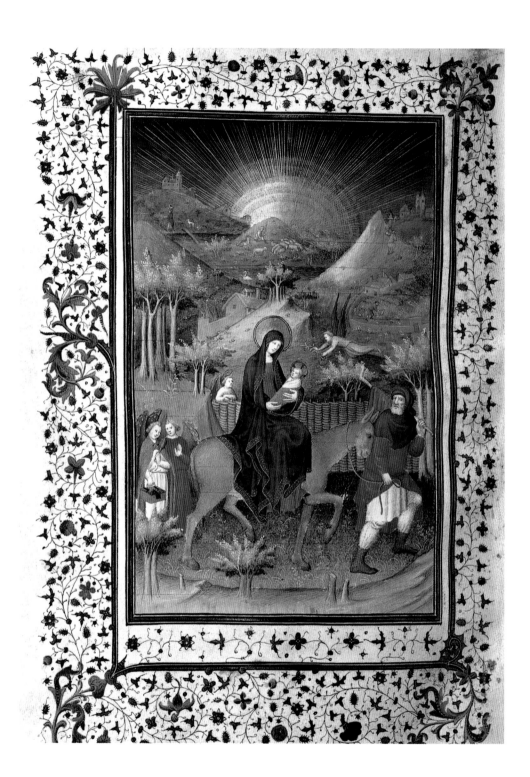

his left foot. At the same time, the concentration of the longest rays of the sun over the head of the Child and the beams of light that emanate in his direction from the hermit's lantern leave no doubt as to the infant's divine nature.

Multiple scales also play an important role in the unfolding narrative on the Getty page with *The Flight into Egypt* [FIGURE 16]. The presentation of the traveling Holy Family in the foreground resembles that in numerous early-fifteenth-century Parisian Flights, among them the rendition in the Boucicaut Hours [FIGURE 49]. On that page the inanimate border decoration and the elements beyond the Holy Family in the miniature itself—the townscapes, the man working in an enclosed field, the swan on the distant body of water, the shepherd and his flock beyond the water, and the man and woman carrying burdens on their shoulders and heads in the distance—serve only to foil the narrative moment rendered in the illumination's foreground.

The Getty book's borders, by contrast, accommodate the next episode in the story, the Miracle of the Wheat Field. At the same time, the soldiers approaching Bethlehem in the miniature's background seem ominously to remind us of the event that followed the miracle, the Massacre of the Innocents. The depiction of the Getty manuscript's city also serves to emphasize its role in the narrative. In the Boucicaut miniature, the rendition of the middle ground and background in muted shades of blue, green, and ocher underscores both their distance from the viewer and their role as backdrops. By contrast, the pink walls, blue roofs, and golden finials and highlights of the Spitz Hours Bethlehem both implicitly draw the city into the foreground and remind us of its critical place in the unfolding story. Because the soldiers are key players in the narrative of the Flight, they are improbably large in scale when compared with the two shepherds just in front of them.

The emphasis in the Spitz Hours on unifying decorative pattern and expanded narrative is also evident in the handful of miniatures that rely on those in the *Très Riches Heures*. That book, it will be remembered, was painted by the Limbourg brothers for John of Berry between about 1411 and 1416.

A number of details in the three brothers' *Nativity* [FIGURE 50] resurface in the same subject in the Getty book [FIGURE 13]. The most obvious similarities in the foreground are the Virgin's kneeling pose and white headdress, the presentation both of the Infant and of the solicitous angels who encircle him, and the shed with its open dormer behind the Virgin. Comparable details in the middle ground include the grazing sheep on the knoll just visible beneath and beyond the shed's thatched roof, the hillock dotted with shepherds and their charges behind Joseph, and the statue of a nude pagan god atop a pillar between and beyond the shepherds and shed. One may also compare the citadel atop the rise on the horizon and the apparition of the Lord at the subject's apex.

75

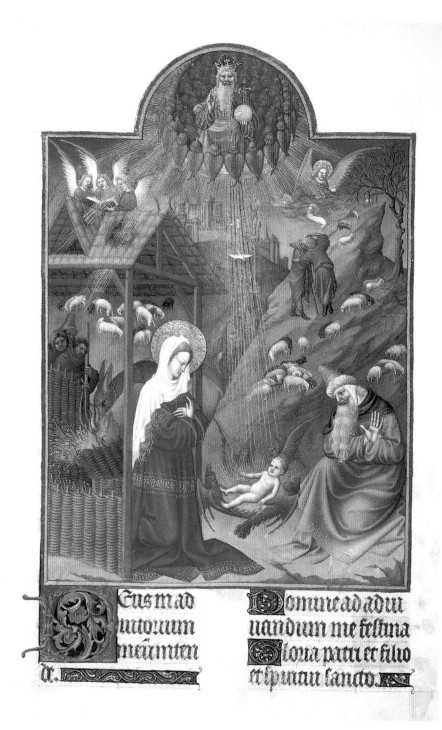

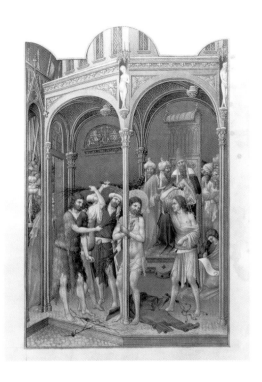

As always, however, the differences between the two images are more instructive than their similarities. In the *Très Riches Heures*, Joseph simply gazes in amazement both at the Child and at the ring of angels that surrounds him; he wears a hat over a skullcap. By contrast, in the Getty book, Joseph's worshipful pose and doffed hat make it clear that he recognizes his son's divinity just as Mary and Anastasia do. As a consequence, all three figures have halos. In the Limbourgs' image, the golden idol in the middle ground stands alone at a crossroads; in the Spitz Master's miniature, two men kneel before it just as the Virgin, Joseph, and Anastasia kneel before the infant Savior. That the idolatry of the two is false is made clear both by the absence of paths leading to the statue and by the hats on the irreverent infidels' heads.

The architectural setting and core figures in the Spitz Hours *Flagellation* [FIGURE 22] closely resemble the same elements and characters in the *Très Riches Heures* [FIGURE 51]. While the Spitz Master's shaving of the pate of the Limbourgs' rightmost flagellator is rather startling, the changed garb of the leftmost flogger is even more interesting. In the *Très Riches Heures*, that figure is bearded and clad in animal pelts belted at the waist; in the Getty miniature, he is clean shaven and wears a garment of woven stuffs. Was the Spitz Master uncomfortable with the puzzling resemblance of the Limbourgs' figure to John

Figure 51

Limbourg Brothers, *The Flagellation. Très Riches Heures,* fol. 144 (see Figure 33). © Réunion des Musées Nationaux / Art Resource, New York.

77

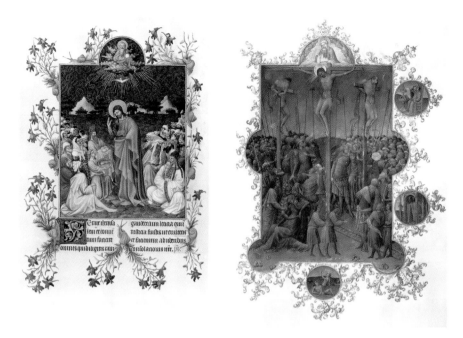

the Baptist, who is said in the Gospels to have worn a rough coat of camel's hair and a leather girdle? Whatever the reason for the costume change, there is nothing surprising about the more lavish floor tiling, gold-starred vaults, or gold-threaded cloth of honor hung behind the throne of the Roman procurator in the Getty miniature, for these embellishments are entirely in keeping with the Spitz Master's taste for decorative enrichment.

The Spitz Master and his team were also familiar with the ancillary decoration in the *Très Riches Heures*. For example, the stylized gold acanthus that undulates against the blue backdrop of the Getty *Deposition* [FIGURE 24] is a less plastic variant of an acanthus that foils a number of illuminations in the *Très Riches Heures*, among them the depiction of *Christ Feeding the Five Thousand* [FIGURE 52]. Gigantic snails crawl across and next to sprigs of forking larkspur in the largely empty margins surrounding that miniature and its accompanying text. Disconcertingly large snails also ascend the tree trunks before the Getty *David* [FIGURE 19] and crawl through the border foliage that encloses the three miniatures that follow it [FIGURES 20–22]. The different species of parti-colored acanthus that frame both those three Spitz Hours illuminations and the subsequent image of *The Celestial Virgin and Child* [FIGURE 23] resemble that on the page with *The Death of Christ* in the *Très Riches Heures* [FIGURE 53].

Brilliant polychromy and dense surface patterning also characterize the Spitz Master's latest illuminations, the six that he contributed to the Hours

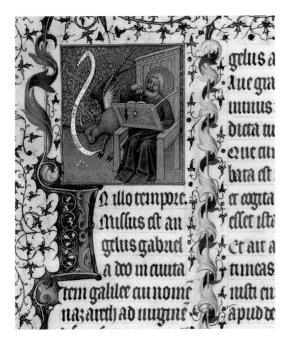

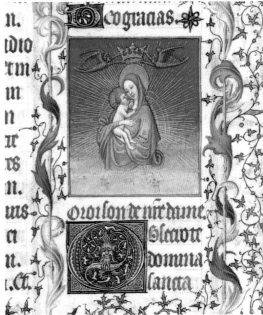

of Charlotte of Savoy in the Morgan Library. Written for use in Paris and made there between about 1420 and 1425, the Morgan book entered the collection of Charlotte of Savoy, wife of King Louis XI of France, in the third quarter of the fifteenth century. It was she who had the acanthus in the quatrefoils at the corners of the pages painted over with the arms of Savoy (a silver Greek cross on a red ground) and of France (three gold fleurs-de-lis on a blue ground) [FIGURES 59 and 61].

As do one or another of his four colleagues in the corresponding Getty image [FIGURE 4], the writing Luke in the Morgan manuscript [FIGURE 54] occupies a wooden chair with a sloping desk. The folds of his garment shimmer with gold highlighting, a luxuriant carpet of greenery lies at his feet, and a red curtain enriched with gold scrollwork hangs behind him.

The *Obsecro te* in the Hours of Charlotte of Savoy [FIGURE 55] is introduced by an image of the Virgin and Child in glory that invites comparison with the Virgin and Infant glorified in heaven in the Getty manuscript [FIGURE 23]. While the poses of Mother and Child are identical, the Morgan pair seems to rise up at the horizon above a pale green lawn. The spray of golden rays that encircles the two fills the deep blue firmament behind them; a warm pink glow just above the horizon signals that dawn is imminent. As in the Spitz Hours *Coronation* [FIGURE 17], a crown is lowered onto the Virgin's head, here by two wispy red angels.

Figure 54

Spitz Master, *Saint Luke Examining His Pen* [detail]. Hours of Charlotte of Savoy, Paris, between ca. 1420 and 1425. Tempera and gold on parchment, 174 leaves, 22 × 15.5 cm (8⅝ × 6⅛ in.). New York, Morgan Library, M.1004, fol. 8.

Figure 55

Spitz Master, *The Virgin and Child in Glory* [detail]. Hours of Charlotte of Savoy, fol. 10v (see Figure 54).

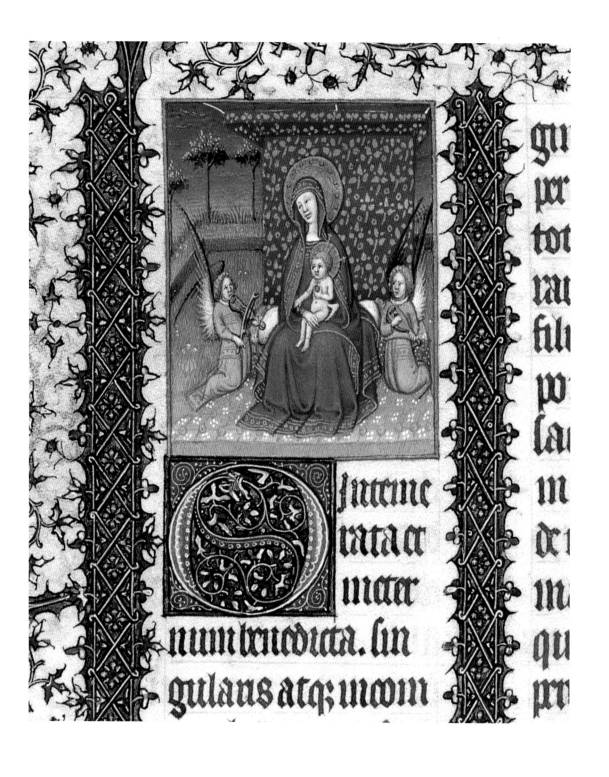

grī
prī
tor
rau
fili
pō

Interne
rata et
mater

num benedicta. sin

gulans atq; incom

sla
m
de
m
qu
pr

Music-making angels serenade the Virgin and Child in an enclosed garden in the miniature that prefaces the *O intemerata* in the Hours of Charlotte of Savoy [FIGURE 56]; the same subject, it will be remembered, introduces the *Obsecro te* in the Getty manuscript [FIGURE 6]. A bright red cloth of honor threaded with gold hangs behind the Morgan figures, who rest on a pale purple tapestry densely strewn with gold and white flowers that recalls the cloth draped over the throne of the Lord in the Getty book's *Coronation* [FIGURE 17].

The quality of the Morgan miniatures notwithstanding, it is obvious that the Spitz Master played only a minor role in the making of the Hours of Charlotte of Savoy: he painted none of the book's thirteen large miniatures and clearly had no influence over its layout or decorative scheme. As a consequence, the mature Spitz Master's skills as a designer and storyteller are most evident in the Getty manuscript.

THE COLLABORATORS OF THE SPITZ MASTER

Both *The Visitation* [FIGURE 12] and *The Presentation* [FIGURE 15] in the Spitz Hours are the work of a follower of the Boucicaut Master known as the Master of the Harvard Hannibal. The artist was named after a miniature of the celebrated Carthaginian general in a copy of Livy's history of Rome (*Ab urbe condita libri*) in the Harvard College Library (Ms. Richardson 32); he produced most of his work in Paris between about 1415 and 1425. While the hand of the Spitz Master has been found only in three books, the Hannibal Master has been identified in no fewer than twenty manuscripts.

The Getty *Visitation* invites comparison with the same subject by the Hannibal Master in a book of hours made around 1420 and now in the Bibliothèque nationale de France [FIGURE 57]. In contrast with the figures of the Spitz Master, which rarely are even half as tall as the miniatures they occupy, the Virgin and Elizabeth in the Getty and Paris *Visitations* are nearly two-thirds the height of the illuminations themselves. The two women are also considerably more substantial than the figures of the Spitz Master, and their physiognomies are less markedly round.

On the other hand, the Hannibal Master's landscapes are not as expansive as those of the Spitz Master. Miniature trees and toy-sized windmills teeter atop precarious outcrops that seem to rise only a few yards behind the foreground figures; cutout houses and townscapes with eye-catching roofs loom just beyond those staggered rises. At the same time, both the Spitz and Hannibal Masters enjoy speckling their skies with golden stars and crowning them with suns that emanate fans of shimmering rays.

Figure 56
Spitz Master, *The Madonna and Child in an Enclosed Garden* [detail]. Hours of Charlotte of Savoy, fol. 13v (see Figure 54).

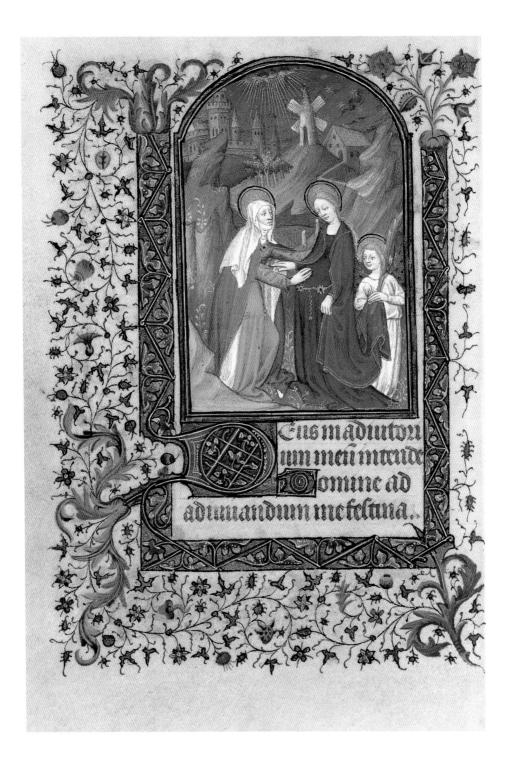

As in the Getty Visitation, stumpy rays model the halos in the Hannibal Master's *Presentation* in the same manuscript [FIGURE 15]. The figures in the Getty *Presentation*, on the other hand, mirror their counterparts in another book of hours by the artist painted in Paris between about 1420 and 1425 and now at Stonyhurst College in Clitheroe, Lancashire, England [FIGURE 58]. Both the Getty and Stonyhurst *Presentation*s also unfold in chapels with leaded-glass windows and ribbed vaulting that rests partly on slender freestanding columns. However, the heavy black strokes between the lips, along the nose, and around the eyes of the high priest's companion in the Spitz Hours are uncharacteristic of the artist; was that physiognomy overpainted at a later date?

The borders of the Hannibal Master's two miniatures in the Getty book contain figures by the Spitz Master's team and present the same dense mix of parti-colored acanthus, scattered *rinceaux*, and blossoms that one finds circumscribing all fourteen illuminations by the Spitz Master that are above three lines of text except for *The Virgin and Child Enthroned* [FIGURE 6]. Given this, it seems most likely that the pages with the Visitation and Presentation were handed over to the Hannibal Master with the texts, decorated initials, and borders already completed. If the proposed dates for the Paris and Stonyhurst Hours illustrated by the Hannibal Master are close to the mark, the artist painted his two contributions to the Getty manuscript around 1420, and thus most likely soon after the Spitz Master completed his work.

Although their petite dimensions make attribution difficult, the small Getty miniature of the crucified Savior [FIGURE 3] and the historiated initials of *Saint Sebastian* [FIGURE 9], *Saint Anthony Abbot* [FIGURE 10], and *The Virgin and Child in an Enclosed Garden* [FIGURE 18] all appear to be the work of another follower of the Boucicaut Master, the Master of the Guise Hours. Named after a book of hours in Chantilly (Musée Condé, Ms. 64) that was owned in the sixteenth century by François de Lorraine, duke of Guise, the painter practiced his craft in Paris in the second and third decades of the fifteenth century.

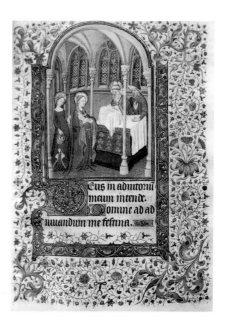

Figure 58
Master of the Harvard Hannibal, *The Presentation in the Temple*. Book of hours, Paris, ca. 1430. Tempera and gold on parchment, 178 leaves, 20 × 14.5 cm (7 7/8 × 5 3/4 in.). Clitheroe (Lancs.), Stonyhurst College, Ms. 33, fol. 47.

Opposite
Figure 57
Master of the Harvard Hannibal, *The Visitation*. Book of hours, Paris, ca. 1420. Tempera and gold on parchment, 145 leaves, 16.8 × 12.2 cm (6 5/8 × 4 3/4 in.). Paris, Bibliothèque nationale de France, n.a.l. 3109, fol. 23v.

In the Initial *S* with *The Martyrdom of Saint Sebastian* [FIGURE 9], the saint embodies the Guise Master's characteristic older male type and the two archers his typical younger male ones. This can be seen by comparing the three with some of the apostles in a *Pentecost* by the artist in the Hours of Charlotte of Savoy [FIGURE 59]. That book, it will be recalled, contains the latest surviving miniatures by the Spitz Master [FIGURES 54–56]; the Guise Master's contribution comprises three large miniatures altogether.

Both the older and younger male physiognomies in the Getty *Saint Sebastian* and Morgan *Pentecost* are insistently uniform. The older men have similarly rectilinear physiognomies and the younger men comparably round ones, and many of the figures turn their heads at similar angles. All have chalky complexions and suffer from partly receding hairlines; what remains of their hair is combed into clumps resembling wound rope. The short lines that describe their mouths are either straight or curve slightly downward, with the consequence that all look rather glum. With his bifurcated white beard and dour expression, the standing Saint Anthony in the historiated initial *V* [FIGURE 10] is cut from the same cloth as the apostles in the Morgan *Pentecost*. The Virgins in the Morgan *Pentecost* and in the Getty initial *S* [FIGURE 18] also share the same downturned heads, heavy upper eyelids, and small mouths with fleshy lips.

One large Getty miniature, *The Entry into Jerusalem* [FIGURE 2], also appears to be at least partly the work of the Guise Master. The physiognomies of the older men—no women are present—are comparable with those of the same figures both in the small Getty illustrations [FIGURES 9–10 and 18] and in the Morgan Pentecost [FIGURE 59]. In addition, the youths who greet Christ in the Spitz Hours miniature resemble the unbearded apostle—most likely John—immediately to the Virgin's left in the Morgan illumination.

On the other hand, the Getty *Jerusalem* is almost a mirror image of the Jerusalem in the Spitz Master's rendition of *The Way to Calvary* in the same manuscript [FIGURE 5]. And, while the uniformly pale flesh tones of the Guise Master's figures in the small miniature and historiated initials in the Getty book are analogous to those in the Morgan illumination, the complexions in the Getty *Entry* are considerably duskier. Did the artist deepen the complexions of the older men in order better to harmonize his one large miniature with the eighteen large ones of the principal illustrator, the Spitz Master? When taken altogether, the evidence suggests that the Getty *Entry* was designed by the Spitz Master and completed by the Guise Master.

Both the initial letter *I* beneath the Getty *Entry into Jerusalem* and the border that surrounds it differ in style from all the others in the book. While the initial is formed from interwoven red and blue acanthus, the inner and outer borders are dominated not by riotously colored acanthus leaves or *rinceaux*, but

84

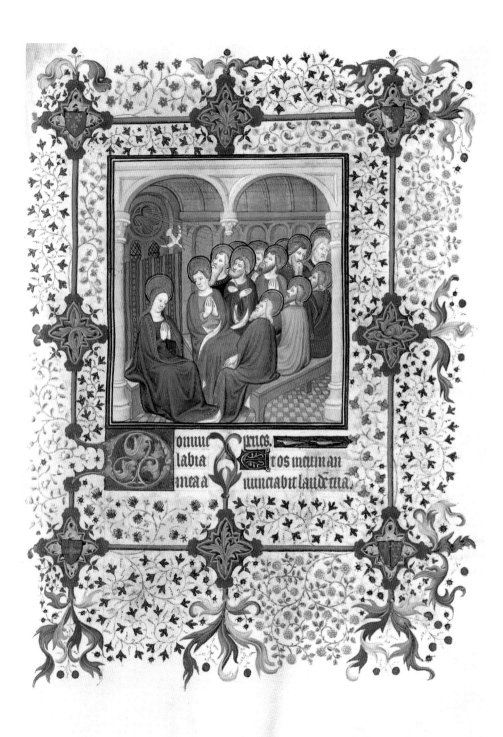

onine rics.
labia ros meum an
mea a nunciabit laud tua.

rather by long blue and pea green stems. These sprout acanthus leaves in blue, pea green, and red together with flowering shoots separated by fanciful pods and buds. Of the flowering shoots, three can be identified: the roses at the top of the outer border, the violets just below them, and the pinks in the flowerpot in the lower border. Those pinks are the only blossoms in the manuscript to attract dragonflies and butterflies; the border is also one of the few not to contain figures by the Spitz Master's team.

Initials comparable to that beneath the Getty *Entry* appear throughout the *Très Riches Heures*; one example is the initial *D* beneath *The Nativity* [FIGURE 50]. Such initials also introduce the texts in another book with miniatures by the Guise Master, the Hours of Charlotte of Savoy [FIGURE 59]. Borders like that of the Spitz Hours *Entry into Jerusalem* are found in numerous manuscripts made in Paris between about 1415 and 1440; an example with much less *rinceaux* encloses a Parisian miniature of about 1420 to be considered in the next chapter [FIGURE 62].

It will be remembered that the initials and borders on the Getty manuscript's pages with *The Visitation* and *The Presentation* by the Harvard Hannibal Master [FIGURES 12 and 15] match those on the pages illustrated by the Spitz Master, a circumstance that suggests that the *Visitation* and *Presentation* pages were sent to the former artist with only the miniatures lacking. Given that the styles of the initial and borders surrounding the Getty *Entry into Jerusalem* are closer to those in other manuscripts illustrated by the Guise Master, it seems most likely that the *Entry* page was dispatched to the artist with only the text and the drawing of the miniature completed. This implicit vote of confidence in the Guise Master suggests that he and the Spitz Master collaborated on more than just the Getty Museum and Charlotte of Savoy Hours.

THE SPITZ HOURS AND
PARISIAN MANUSCRIPT ILLUMINATION

In the preceding chapter it was argued that the Getty manuscript was illustrated by three discrete Parisian illuminators. All the evidence suggests that the three executed their respective contributions around 1420 and most likely over a short rather than a long period of time. The contributions of the Harvard Hannibal and Guise Masters comprise altogether three large miniatures, one small miniature, and three historiated initials; all eighteen of the remaining large illuminations are the work of the Spitz Master.

We also learned in the last chapter that the Spitz Hours is one of only three manuscripts, all books of hours, with miniatures by the Spitz Master. The earliest, the manuscript in Chantilly [FIGURES 34, 37, and 39–40], was illustrated around 1415, some five years before the Getty volume. The latest, the Hours of Charlotte of Savoy in the Morgan Library [FIGURES 54–56], was painted between about 1420 and 1425, thus shortly after the Getty manuscript.

Finally, it was argued in the preceding chapter that the mature representations of the Spitz Master are more easily read as copiously decorated two-dimensional surfaces than as windows opening onto three-dimensional panoramas. In this respect, the Getty and Morgan miniatures represent a retreat from the greater verisimilitude both of the Chantilly paintings and of the Limbourg models that the Spitz Master so admired. To be sure, an emphasis on line and pattern was already a countercurrent in Parisian illumination even before the Limbourg brothers and Boucicaut Master had passed from the scene, as the Mazarine page with *The Annunciation to the Shepherds* makes clear [FIGURE 45].

What is striking about the shift in the Spitz Master's style around 1420, however, is that it came at just the time that Paris's book painters as a whole suspended the effort to master depth in favor of an emphasis on surface decoration. That emphasis is the identifying characteristic of Parisian illumination in the third and fourth decades of the fifteenth century; not until the fifth decade would

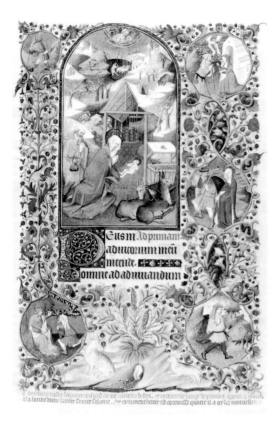

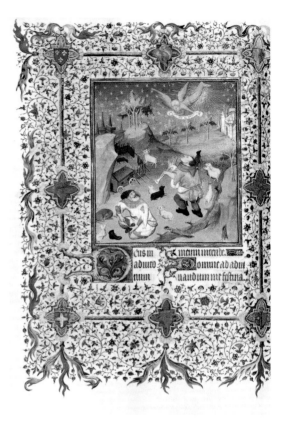

Figure 60

Master of the Duke of
Bedford (French, fl. ca.
1405–40), *The Nativity.*
Tempera and gold on
parchment, 26 × 18.5
cm (10 ¼ × 7 ¼ in.).
Bedford Hours, ca.
1423. London, British
Library, Additional MS
18850, fol. 65.

Figure 61

Master of Morgan 453
(French, act. ca. 1415–
35), *The Annunciation
to the Shepherds.* Hours
of Charlotte of Savoy,
fol. 44v (see Figure 54).

more adventurous Parisian book painters recommence the drive for spatial veracity.

The perfect embodiment of the interregnum is the highly prolific Bedford Master. Active already in the second decade of the century, the artist takes his name from two sumptuous manuscripts made for John of Lancaster, duke of Bedford and regent of France from 1422 until his death in 1435. They are a book of hours in the British Library, completed about 1423 to commemorate John's marriage to Anne of Burgundy, and a breviary in the Bibliothèque nationale de France (lat. 17294), undertaken in 1424 and still unfinished at the duke's passing. The Bedford Master also collaborated with the Spitz and Guise Masters on the Hours of Charlotte of Savoy. In the book of hours in the British Library, the Bedford Master rendered *The Nativity* in a snow-dusted landscape [FIGURE 60]. While the upward tilt of the ground plane is more exaggerated than any in the Spitz Master's oeuvre, the telescoping spatial recession, the crowding of the landscape from bottom to top with decorative details, and the dense historiated borders find many parallels in the Getty manuscript.

88

Eccentric polychromy and an almost profligate use of gold highlighting are the hallmarks of another of the Spitz Master's collaborators in the Hours of Charlotte of Savoy, the Master of Morgan 453. Named after a book of hours in the Morgan Library (M.453), the artist first appears in Paris around 1420 as a collaborator with the Boucicaut Master on a third book of hours in the Morgan collection (M.1000). Around 1430 the Morgan 453 Master appears to have migrated to Amiens in northern France, where he worked for another decade or so before disappearing from the scene.

One of his three full-page contributions to the Hours of Charlotte of Savoy is *The Annunciation to the Shepherds* at Terce [FIGURE 61]. There the wheels of the shepherds' cart and the horns of the nearby ram are improbably and eye-catchingly rendered in gold, as are the finials on the tiny towers of the exquisite charcoal gray cityscape just beyond them. The abrupt spatial recession and the almost mathematically even spacing of the gold stars in the firmament further amplify the miniature's winsome charm.

In the seven illustrations by the Morgan 453 Master for the Hours of the Holy Spirit in Morgan 1000, the polychroming and gilding of structures both far and near are even more delightful. At Vespers, for example, the Lord appears to two apostles—most likely Peter and John—outside a citadel of pink stone [FIGURE 62]. One house within the walled city is built of green stone and roofed in red, while others have pink walls and blue, red, or green roofs. All the structures shimmer with gold finials, grouting, and highlights; gold stars twinkle in the blue sky beyond the town.

With their pink and pale purple walls, pitched blue roofs, bulging blue onion domes grouted in gold, and sparkling gold finials, the depictions of the city of Bethlehem on the horizons of the Spitz Hours *Annunciation to the Shepherds* [FIGURE 14] and *The Flight into Egypt* [FIGURE 16] could have been built by the same highly imaginative architect responsible for the Morgan 1000 stronghold. The richly embellished arch rendered in pink in the Getty *Annunciation* [FIGURE 11] recalls the gold one surmounting the city gate in the illumination in Morgan 1000. A building permit for the pink and green tower at the apex of the Getty manuscript's *Annunciation* could easily have been obtained from the authorities who approved the erection of the citadel behind the two Morgan 1000 apostles. We know that the Spitz Master and Morgan 453 Master worked together on the illustration of the Hours of Charlotte of Savoy; might the former artist have invited the latter master to paint the dazzling townscapes in the Getty manuscript?

Whatever the answer to that question, a more pressing one still remains: why did the Spitz Master and other Parisian illuminators turn as a whole to less naturalistic styles in the third and fourth decades of the fifteenth century? While a conclusive answer to this question may forever elude us, a

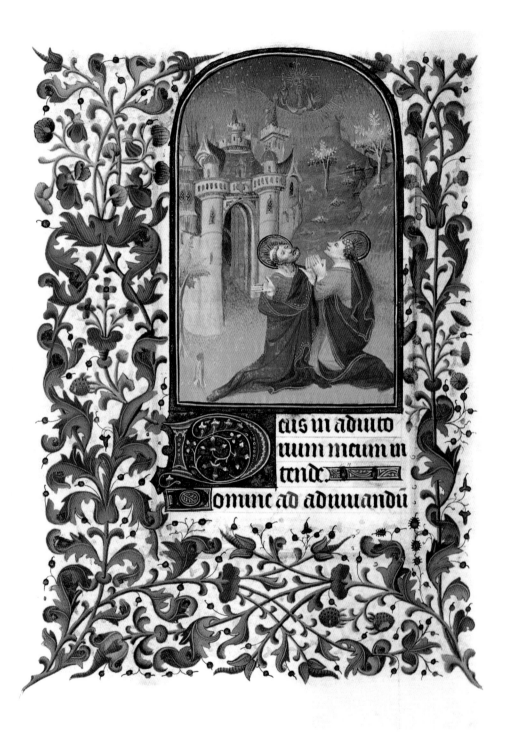

eus in adiuto
rium meum in
tende.
Domine ad adiuuandu

consideration of the economic and political situation in Paris at that time may enable us to form some hypotheses.

In the preceding chapter, we learned that Paris had been the leading northern European center for the production of manuscripts for almost two centuries when the Limbourg brothers migrated there to practice their craft. Unfortunately, events connected to the Hundred Years' War cost Paris its primacy in this regard at the very time that the Spitz Master and his colleagues were illuminating the Getty manuscript.

The Hundred Years' War was the conflict between England and France between 1337 and 1453 that grew out of the English kings' claim to be the rightful rulers of France. Forty years into the conflict, England's hand was greatly strengthened by the ascension to the French throne in 1380 of Charles VI, whose intermittent bouts of mental illness encouraged manipulative power plays by various French noble factions. Emboldened by the weakened authority of the crown, the English king Henry V invaded Normandy in August 1415 and the following October delivered a devastating defeat to France's defenders at Agincourt. In 1418, as the incapacitated Charles sat helplessly by, the noble French faction loyal to Duke John the Fearless of Burgundy seized Paris, forcing Charles's son and successor, the future Charles VII, to flee to Bourges in central France. When loyalists of the exiled Charles murdered John the Fearless in 1419, John's son, Philip the Good, took his revenge by signing in May 1420 the Treaty of Troyes, which proclaimed Henry V both regent of France and heir to its throne upon Charles VI's death. On the first of December of the same year Henry made his triumphal entry into Paris with Charles VI alongside him.

Although he was held captive in Paris until the end of his days, Charles did manage to outlive Henry by two months; the latter died in August 1422 and the former the following October. By doing so, Charles at least succeeded in depriving Henry of the pleasure of ever wearing his crown. As Henry's son, the future Henry VI, was only an infant, the regency of France was assumed by Henry V's brother John, duke of Bedford, whose book of hours in the British Library we have just considered [FIGURE 60]. Thus from 1422 until 1435 France north of the River Loire was ruled from Paris by an English nobleman, while France south of the Loire was ruled from Bourges by Charles VII, the oldest surviving son of Charles VI. Not until 1436 was the younger Charles finally able to reenter Paris.

What did all this mean for Paris itself? On the one hand, the English garrison was small and relatively unobtrusive, and Frenchmen, especially Burgundians, held most state and municipal offices. On the other hand, the occupying English were still foreigners whose behavior and French-language skills probably often left much to be desired. These realities and the continuing hostilities with "free France" south of the Loire led to material privations and

91

economic difficulties in the capital that, ultimately, must have reaffirmed the Parisians' fundamental sense of loyalty to France herself.

More important for this study, what did the occupation of Paris mean for its book painters? With the better part of the French royal court and administration exiled to Bourges, a major source of local patronage had evaporated. To be sure, the duke of Bedford established his own court in Paris and commissioned works of art from local illuminators, among them the Bedford Master [FIGURE 60]. To judge from the sizable migration of Parisian book painters to provincial French centers in the third decade of the fifteenth century, however, the English occupation of Paris was no golden age for those who illuminated manuscripts.

In addition to the two previously mentioned books illuminated by the Bedford Master, a third splendid manuscript commissioned by the duke of Bedford has come down to us, a psalter-hours now in the British Library [FIGURE 63]. One of the masterpieces of early-fifteenth-century English illumination, the third Bedford book was made in Westminster or London around 1420. The initial *B* that introduces the first psalm in the London manuscript is historiated with the anointing of David by the prophet Samuel. Like the polychromy in the contemporary miniatures of the Morgan 453 and Spitz Masters, the color scheme in the initial is brilliant, the landscape and its numerous elements disorientingly scaled, and the sky densely peppered with golden stars arrayed in improbably tidy ranks. Other subjects set outdoors in the Bedford Psalter-Hours dispense with even the semblance of a panorama: in the initial *C* that introduces Psalm 97, a second painter identified with the documented London illuminator Herman Scheerre confines David and two men carrying the Ark of the Covenant to a shallow strip of greenery before a riot of gold scrollwork [FIGURE 64].

The Spitz Hours and many other manuscripts made in Paris around and after 1420 may well have been commissioned by English men or women living in English-held northern France. Given the conservatism of contemporary book painting across the Channel, might the shift to more decorative and less naturalistic images in Paris after 1420 reflect in part the influence of English tastes?

Whatever the case, the result of the move away from earlier Parisian naturalism in the Getty illuminations by the Spitz Master is to make those paintings seem more like dazzling metaphysical apparitions than extensions of material reality. In a classic 1951 study entitled *Painting in Florence and Siena after the Black Death*, Millard Meiss showed how the chastened survivors of the bubonic plague that devastated those central Italian cities beginning in 1348 moved away from the greater naturalism championed by earlier fourteenth-century masters such as Giotto and Pietro and Ambrogio Lorenzetti in favor of a renewed emphasis on the medieval fundamentals of line, pattern, and formal repetition. Might the greater conservatism of Parisian illumination in the years around and after

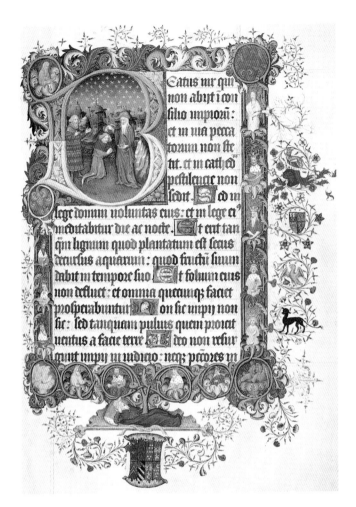

1420 reflect not a willingness or desire to accommodate English tastes but rather a specifically French wish to return to the sureties of tradition in response to the uncertainties of foreign occupation? Or might both of those forces, perhaps together with others, have been at work?

Whatever the answers are to these questions, the Spitz Hours clearly marks a watershed in the history of late medieval French painting. Even more important, the book stands fully on its own as a sophisticated and accomplished work of art. Its early-fifteenth-century Parisian makers wrote its texts to be read and contemplated and painted its decoration to educate, edify, and delight. Although the texts of the Spitz Hours may no longer be read, its decoration continues to delight viewers today as it did past generations and surely will future ones.

THE SPITZ HOURS:
PHYSICAL DESCRIPTION

Los Angeles, J. Paul Getty Museum,
Ms. 57, 94.ML.26
Book of Hours, in Latin and French
Paris, ca. 1420

I. PHYSICAL CHARACTERISTICS

Support and Dimensions: Parchment, 247
 leaves (20.3 × 14.8 cm [7 ¹⁵⁄₁₆ × 5 ⁷⁄₈ in.]).

Collation: 1 ¹² (1–12), 2 ¹⁰ (13–22), 3 ² (23–24, fab-
 ricated bifolio?), 4–5 ⁸ (25–40), 6 ⁹ (41–49,
 folio 49 inserted), 7–11 ⁸ (50–89), 12 ⁷ (90–96,
 leaf between folios 93–94 excised), 13–16 ⁸
 (97–128), 17 ⁹ (129–37, folio 137 inserted),
 18–19 ⁸ (158–53), 20 ⁷ (154–60, leaf between
 folios 160–61 excised), 21 ⁸ (161–68), 22 ⁵
 (169–73, construction uncertain), 23 ⁶ (174–
 79), 24 ⁷ (180–86, leaf between folios 186–
 87 excised?), 25–31 ⁸ (187–242), 32 ⁵ (243–45,
 construction uncertain), 33 ² (246–47,
 added bifolio); partial horizontal catch-
 words visible in the lower right-hand
 corners of the versos of folios 12, 22, 173,
 179, and 243.

Textblock: One text column of fourteen lines
 (9.5 × 6.5 cm [3 ¾ × 2 ⁹⁄₁₆ in.]).

Languages and Script: Latin and French, in
 littera textualis formata.

Miniatures and Historiated Initials: One full-
 page miniature (folio 176v: 13 × 7 cm

[5 ¹⁄₁₆ × 2 ¹¹⁄₁₆ in.]); two three-quarter-page
 miniatures (folio 170v: 10.2 × 6.5 cm [4 ×
 2 ⁹⁄₁₆ in.]; folio 172v: 11.5 × 7 cm [4 ½ ×
 2 ¹¹⁄₁₆ in.]); eighteen half-page miniatures
 (approximate dimensions: 9.5 × 6.5 cm
 [3 ¾ × 2 ⁹⁄₁₆ in.]); one small miniature (folio
 22v: 2.7 × 2 cm [1 ¹⁄₁₆ × ¾ in.]); three histo-
 riated initials, the two occurring on rectos
 (folios 49 and 130) with marginal *rinceaux*
 sprays (line heights as in TEXTS AND
 MINIATURES, below).

Decorated Borders: Four-sided floral borders
 on all miniature pages (approximate
 dimensions: 16.5 × 12.5 cm [6 ½ × 4 ⁷⁄₈ in.]);
 four-sided *rinceaux* borders on all text
 pages with three-line colored initials
 (approximate dimensions: 14.5 × 10.5 cm
 [5 ⁵⁄₈ × 4 ⅛ in.]); three-sided *rinceaux* bor-
 ders on all other text pages (approximate
 dimensions: 14.5 × 9.5 cm [5 ⁵⁄₈ × 3 ¾ in.]).

Decorated Initials: One three-line acanthus
 initial on decorated gold ground (folio 13);
 numerous two- to three-line colored ini-
 tials patterned in white on decorated gold
 grounds, the two-line initials on the rectos
 of text pages embellished with marginal
 rinceaux sprays; numerous one-line gold
 initials on colored grounds patterned in
 white; numerous colored-ground line end-
 ings patterned in white with gold.

Binding: Red silk velvet over pasteboards,
 after 1958.

II. TEXTUAL CHARACTERISTICS

Calendar: In French, with feasts for every
day of the year, written in alternating red
and blue with feasts of high grading writ-
ten in gold. Of the strictly local feasts,
seven are for Paris, although none are
in gold (Paula, January 29; Honorina,
February 27, also celebrated in Rouen;
Justin, February 28; Landericus, June 10;
Clodoaldus, September 7; Cerbonius,
October 17; and Genevieve, "De miraculis
ardentium," November 26). There is
also one feast for Senlis (Translation of
Regulus, March 30) and one for Tournai
(Eleutherius of Tournai, February 20).

Hours of the Virgin: For the use of Rome.

Office of the Dead: For the use of Rome.

Litanies: Widely revered saints only.

Suffrages: Widely revered saints only.

III. TEXTS AND MINIATURES

(A = miniature by the Spitz Master; B =
miniature by the Harvard Hannibal
Master; C = miniature or historiated initial
by the Guise Master)

Calendar, French, full (1–12v). First Passion
Passage from John (13–24v): *The Entry into
Jerusalem* (C over design by A, 13); *The
Crucifixion* (C, 22v). Gospel Sequences (25–
30v): *The Four Evangelists* (A, 25). Second
Passion Passage from John, other prayers
and texts (31–33): *The Way to Calvary* (A,
31). *Obsecro te* (33v–37v): *The Virgin and
Child Enthroned* (A, 33v). *O intemerata*
(38–42). Prayer to Saint Christopher, added
in fifteenth-century *littera textualis for-
mata* (42). Suffrages to Saint Christopher
and other saints (42v–45): *Saint Christo-
pher Carrying the Christ Child* (A, 42v).
Prayer to Catherine of Alexandria, added
in fifteenth-century *littera textualis
formata* (45). Suffrages to Catherine of

Alexandria, Michael the Archangel, Peter,
Paul, James, Sebastian, and Anthony Abbot
(45v–49v): *Saint Catherine Tended by
Angels* (A, 45v); *The Martyrdom of Saint
Sebastian*, in four-line initial *S* (C, 48v);
Saint Anthony Abbot, in four-line initial *V*
(C, 49). Hours of the Virgin at Matins (50–
70v): *The Annunciation* (A, 50). Hours of
the Virgin at Lauds (71–83v): *The Visitation*
(B, 71). Hours of the Virgin at Prime (84–
89): *The Nativity* (A, 84). Hours of the
Virgin at Terce, incomplete at end (89v–
93v): *The Annunciation to the Shepherds*
(A, 89v). Hours of the Virgin at Sext,
incomplete at beginning (94–98). Hours of
the Virgin at Nones (98v–103): *The
Presentation in the Temple* (B, 98v). Hours
of the Virgin at Vespers (103v–111v): *The
Flight into Egypt* (A, 103v). Hours of the
Virgin at Compline (112–17): *The Coro-
nation of the Virgin* (A, 112). Hours of the
Virgin at Advent (117–25). Mass of the
Virgin (125–129v). *Salve regina misericor-
die*, other prayers and texts (130–137v):
*The Virgin and Child in an Enclosed
Garden*, in five-line initial *S* (C, 130). Seven
Penitential Psalms and Litany, incomplete
at end (138–160v): *David in Prayer* (A, 138).
Hours of the Cross, incomplete at begin-
ning (161–69). Prayer to Christ, added in
fifteenth-century *littera textualis formata*
(169). Passion Prayers (170–173v): *The
Agony in the Garden* (A, 169v); *The Betrayal
of Christ* (A, 170v); *The Flagellation of
Christ* (A, 172v). Various prayers and texts
(174–76). Prayer to the Virgin (177): *The
Celestial Virgin and Child* (A, 176v). Seven
Verses of Saint Bernard, incomplete, other
prayers and texts (177v–181). *Stabat mater
dolorosa*, other prayers (181v–187):
The Deposition (A, 181v). Hours of the Holy
Spirit (187v–193v): *Pentecost* (A, 187v).
Office of the Dead (194–244v): *A Burial*
(A, 194). Suffrage to Susanna, added in
fifteenth-century *littera bastarda* (244v–
245). Psalms, added in fifteenth-century
littera textualis formata (246–247v).

IV. PROVENANCE

Sir Robert S. Holford, Westonbirt, Gloucestershire, England, acquired ca. 1845; by descent to Lt. Col. Sir George L. Holford, Dorchester House, London (sale, Sotheby's, London, July 29, 1929, lot 7); to Quaritch; Cortlandt F. Bishop, New York (sale, Anderson Galleries, New York, July 25–27, 1938, lot 1409) to Ernst Brummer; in 1947 to Mr. and Mrs. Joel Spitz, Glencoe, Illinois; private collection, United States of America.

V. BIBLIOGRAPHY

G. F. Waagen, *Treasures of Art in Great Britain, Being an Account of the Chief Collections of Paintings, Drawings, Sculptures, Illuminated Mss., &c. &c.*, 3 vols. (London, 1854), vol. 2, pp. 212–14; *Exhibition of Illuminated Manuscripts*, exh. cat. (Burlington Fine Arts Club, London, 1908), no. 207; [Robert H. Benson], *The Holford Collection Illustrated with One Hundred and One Plates Selected from Twelve Illuminated Manuscripts at Dorchester and One Hundred and Seven Pictures at Westonbirt in Gloucestershire* (London, 1924), pp. 9, 38, no. 6, pl. 13; J. Meurgey, *Les Principaux Manuscrits à Peintures du Musée Condé à Chantilly*, Société Française de Reproductions de Manuscrits à Peintures, 14th year (Paris, 1930), p. 72; S. de Ricci and W. J. Wilson, *Census of Medieval and Renaissance Manuscripts in the United States and Canada*, 3 vols. (New York, 1935–40), vol. 2, p. 2525, under "Collection of the Late Cortlandt Field Bishop," no. 65; W. H. Bond and C. U. Faye, *Supplement to the Census of Medieval and Renaissance Manuscripts in the United States and Canada* (New York, 1962), p. 166, under "The Joel and Maxine Spitz Collection of Illuminated Mss.," no. 2; Millard Meiss, *French Painting in the Time of Jean de Berry: The Boucicaut Master* (London, 1968), pp. 146–47, n. 30, fig. 154; idem, *The De Lévis Hours and the Bedford Workshop* (New Haven, 1972), p. 21 n. 53; idem, *French Painting in the Time of Jean de Berry: The Limbourgs and Their Contemporaries* (New York, 1974), pp. 88, 239, 362, 391, 456 n. 274, 462 n. 384, 472 nn. 687–88, figs. 391, 654–56; J. Plummer with G. Clark, *The Last Flowering: French Painting in Manuscripts, 1420–1530, from American Collections*, exh. cat. (New York, Morgan Library, 1982), p. 2 (under no. 2); C. Nordenfalk, "En gåtfull Birgittabild," *Kungelige Vitterhets: Historie och Antikvitets Akadamiens Arsbok*, 1990, pp. 74–76, fig. 6; L. M. C. Randall, *Medieval and Renaissance Manuscripts in the Walters Art Gallery II: France, 1420–1540* (Baltimore and London, 1992), p. 82; "Acquisitions/1994," *The J. Paul Getty Museum Journal*, 23, 1995, pp. 86–88, no. 45, 3 ills.; *Masterpieces of the J. Paul Getty Museum: Illuminated Manuscripts* (Los Angeles, 1997), pp. 78–80, no. 32, two color ills.; Diane E. Booton, "Variation on a Limbourg Theme: Saint Anastasia at the Nativity in a Getty Book of Hours," *Fifteenth-Century Studies*, 29, 2003 (forthcoming).

SUGGESTIONS FOR FURTHER READING

The most informative recent studies of the book of hours both as a book and as a site of late medieval painting are by Roger S. Wieck: *Time Sanctified: The Book of Hours in Medieval Art and Life* (New York and Baltimore, 1988; repr. 2001) and *Painted Prayers: The Book of Hours in Medieval and Renaissance Art* (New York, 1997). In *A History of Illuminated Manuscripts* (Boston, 1986; 2nd ed. London, 1994, repr. 1995), Christopher de Hamel considers the development of medieval illumination as a whole.

For the manufacture of medieval manuscripts, consult Jonathan J. G. Alexander, *Medieval Illuminators and Their Methods of Work* (New Haven and London, 1992); Christopher de Hamel, *Medieval Craftsmen: Scribes and Illuminators* (Toronto and London, 1992); and the same author's *British Library Guide to Manuscript Illumination: History and Techniques* (Toronto and London, 2001). The key overviews of manuscript painting in Paris in the second and third decades of the fifteenth century are Millard Meiss, *French Painting in the Time of Jean de Berry: The Boucicaut Master* (London, 1968) and *French Painting in the Time of Jean de Berry: The Limbourgs and Their Contemporaries* (New York, 1974); John Plummer with Gregory Clark, *The Last Flowering: French Painting in Manuscripts, 1420–1530, from American Collections*, exh. cat. (New York, Morgan Library, 1982); Charles Sterling, *La peinture médiévale à Paris 1300–1500 I* (Paris, 1987); François Avril and Nicole Reynaud, *Les manuscrits à peintures en France 1440–1520* (Paris, 1993); and Albert Châtelet, *L'âge d'or du manuscrit à peintures en France au temps de Charles VI et Les Heures du Maréchal Boucicaut* (Dijon, 2000). To these should be added the popular facsimile of the Limbourg brothers' masterpiece in Chantilly by Raymond Cazelles and Johannes Rathofer (foreword by Umberto Eco), *Illuminations of Heaven and Earth: The Glories of the Très Riches Heures du Duc de Berry* (New York, 1988).

For the Bedford Master, see Millard Meiss, *The De Lévis Hours and the Bedford Workshop* (New Haven, 1972), and Janet Backhouse, *The Bedford Hours* (Toronto and London, 1990). Paris as a center for the making of books is the subject of Richard H. Rouse and Mary A. Rouse, *Manuscripts and Their Makers: Commercial Book Producers in Medieval Paris 1200–1500* (Turnhout, 2000). The history of late medieval English illumination is described in Kathleen L. Scott, *Later Gothic Manuscripts 1390–1490* (A Survey of Manuscripts Illuminated in the British Isles, 6) (London, 1996). Millard Meiss's study of the relationship between the bubonic plague and later fourteenth-century Tuscan painting is fully titled *Painting in Florence and Siena after the Black Death: The Arts, Religion, and Society in the Mid-Fourteenth Century* (Princeton, 1951; repr. 1964, 1973, and 1978). Finally, the political situation in Paris in the third and fourth decades of the fifteenth century is explored in Guy Llewelyn Thompson, *Paris and Its People Under English Rule: The Anglo-Burgundian Regime 1420–1436* (Oxford, 1991).

ACKNOWLEDGMENTS

In the fall of 2000, I approached Thomas Kren, Curator of Manuscripts at the J. Paul Getty Museum, with a proposal to write a text on the Spitz Hours. Having worked and written largely on fifteenth-century Flemish illumination for some ten years, I was eager to return to early-fifteenth-century manuscript painting in Paris, the subject of my 1988 dissertation at Princeton University. Thom encouraged and supported my proposal, put the staff and resources of the Department of Manuscripts at my disposal, and critically read the text; the result is before you.

In addition to Dr. Kren, I would like to thank his Manuscripts Department colleagues Elizabeth Teviotdale, former Associate Curator, now Assistant Director of the Medieval Institute at Western Michigan University in Kalamazoo; Kurt Barstow, Assistant Curator; and Tulis McCall, former Senior Staff Assistant. In Getty Publications I thank my editors, Mollie Holtman, Tobi Kaplan, and Diane Mark-Walker; the book's designer, Jeffrey Cohen; and Mark Greenberg, Editor in Chief. The Institute Francophone de Paris facilitated my study of relevant manuscripts in Parisian collections. At the University of the South, the staff of Print Services—Sondra Bridges, Tracy Hall, Minnie Raymond, Jean Ricketts, and Tammy Scissom—saved the day on many occasions. Patricia Stirnemann, *chercheur* at the Institut de Recherche et d'Histoire des Textes in Paris, and Roger Wieck, Curator of Manuscripts at the Morgan Library in New York, helped with a number of problems and offered valuable advice. Robert Ingram of the University of Virginia and three anonymous reviewers critiqued the penultimate version of the text. The arrival on my desk in July 2002 of an unpublished study by Diane E. Booton helped to further shape the ultimate version of the text.

John Plummer, Curator Emeritus of Medieval and Renaissance Manuscripts at the Morgan Library and Professor Emeritus of Art History at Princeton University, first opened my eyes to the wonders of late medieval French book painting in a graduate seminar at Princeton in 1979. Two years later he invited me to work as his assistant on the catalogue for his 1982 Morgan exhibition, *The Last Flowering: French Painting in Manuscripts 1420–1530*. Over the course of the following six years he advised and nudged to completion my dissertation on the Master of Morgan 453, a Parisian illuminator who collaborated with two of the three painters of the Spitz Hours. For all this I am forever in his debt.

The present study is dedicated to two great French connoisseurs of late medieval French book illumination: Nicole Reynaud, *directeur de recherche honoraire* with the Centre National de la Recherche Scientifique in the Department of Paintings at the Musée du Louvre, and François Avril, *conservateur général* in the Department of Manuscripts at the Bibliothèque nationale de France. Generous colleagues and friends, they have encouraged and facilitated my work in France on manuscripts both French and Flemish for fully twenty years; I only hope that they will forgive the tardiness of this acknowledgment.